PART ONE

YOU CAN PAINT
LANDSCAPES

Cincinnati, Ohio

CONTENTS

HOW TO USE THIS BOOK

Here are step-by-step demonstrations of a range of subjects designed to illustrate some ways of approaching landscapes. To get the most out of these exercises, study each one first and then either re-paint it yourself, or apply the techniques to a subject or scene of your own choice.

Copying. Don't be concerned about copying the exercises — many famous artists have borrowed ideas and painting techniques and have used them to develop their own individual style. Copying the exercises will make learning the techniques easier as you won't have to worry about finding a subject, composition or design.

Stay loose. Attack each painting vigorously and don't worry about making mistakes — the more you practise and experiment, the sooner you will see a dramatic improvement in your painting.

Experiment. Painting boldly and taking risks with lines, colour, shapes and values will prevent your painting looking tight and overworked. Apply paint freely and don't hold your brush too near the point or your brushwork will look tentative. You only need to hold the brush near the bristles when you are working on details. Start your paintings loosely, saving the detailed work for the finishing touches.

Keep it simple. Select simple subjects and compositions to start with. Restrict the number of colours you use and avoid overworking them. If you follow these simple rules you will soon produce surprisingly good paintings and then you can really start to experiment with more ambitious compositions and colour schemes and develop your own unique painting style.
 Happy painting!

A QUINTET BOOK

First published in North America by
North Light, an imprint of Writer's Digest Books
9933 Alliance Road
Cincinnati, Ohio 45242

ISBN 0 89134 139 0

This book was designed and produced by
Quintet Publishing Limited
6 Blundell Street, London N7

Typeset in Great Britain by
Facsimile Graphics Limited, Essex
Colour origination in Hong Kong
Printed in Hong Kong by Leefung-Asco
Printers Limited

PAINTING OUT OF DOORS

One of the joys of watercolour painting is the freedom it gives you to work out of doors. The basic requirements are few and not too heavy and when working on location the emphasis is strongly on compactness and portability. A watercolour box containing dry pans is lighter to carry than bottles or tubes and the open lid provides you with a mixing surface. Some watercolour boxes are especially designed for outdoor work — they are very small and contain only 8-12 colours and a brush which breaks down to fit into the box. Another cleverly designed box is a triumph of ingenuity, it contains an integral waterbottle, the lid of which becomes a water container. Other boxes are so small they fit in your pocket.

Since watercolour should be painted broadly and fast and since every new shade should be mixed separately on the palette you may find the lid of your paintbox a rather restricting mixing surface. A lightweight plastic palette is a useful investment and worth the extra bulk it adds to your luggage.

A drawing board provides a good surface to work on and paper can be stretched on both sides and covered with a protective sheet. If you do not have transport and will therefore have to carry all your equipment yourself heavy duty paper in blocks is a useful alternative to the board and stretched paper.

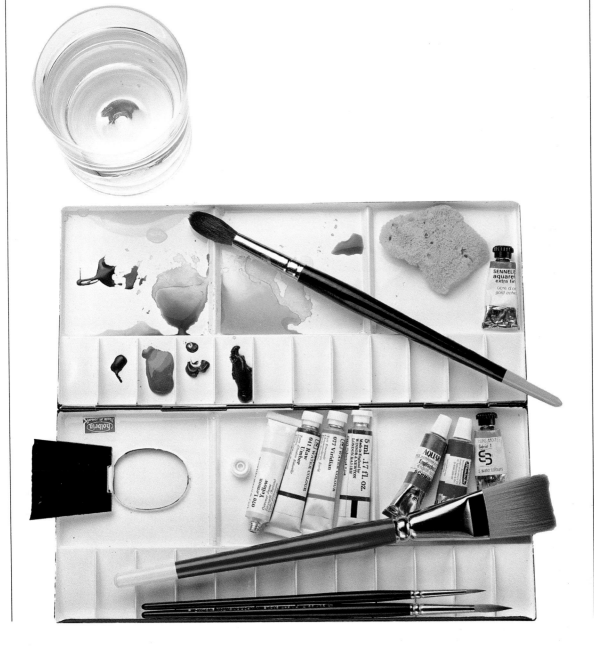

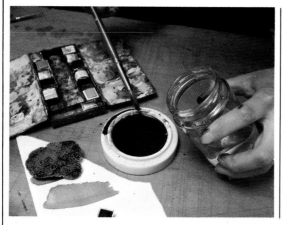

WATERCOLOUR TECHNIQUES

The principle behind nearly all watercolour painting is that of using transparent colour, or making washes. Once that is mastered other techniques will come easily and naturally. Apart from applying a single, flat colour, there are two other types of wash which are extremely useful — the variegated wash and the graded wash. The first involves the use of more than one colour, while the other is one which changes from light to dark of a colour. Practise laying both kinds of wash.

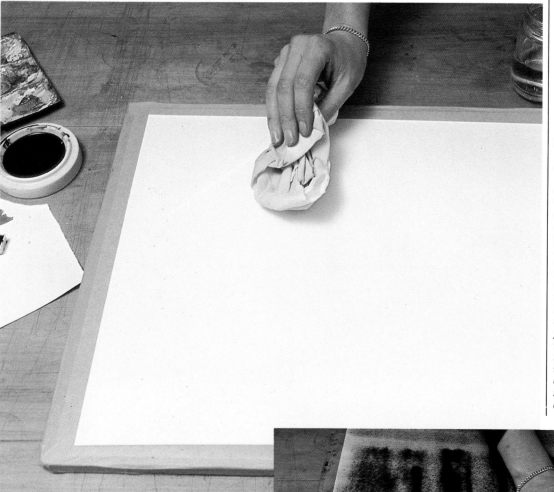

Laying a graded wash. First mix up a quantity of dilute paint in a small container **(far left)**. *Then dampen a sheet of paper with a sponge or a rag* **(centre left)**. *Using a sponge flood colour onto the damp paper, working from left to right with sweeping, horizontal strokes* **(bottom left)**. *The result is a tint which grades from light to dark of the same colour below. This kind of wash can be very useful. A variegated wash can be achieved by flooding a second, or even several colours into the wet paint. The effects are unpredictable and this is one of the characteristics of watercolour. Only practice will tell you how much or how little colour you need to create the particular wash you want. Remember, if a wash goes wrong, do not try to change it while the paint is wet. Only when dry can colours be lifted off by sponging out, or added to by overlaying other washes.*

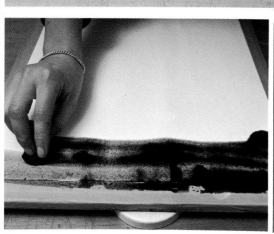

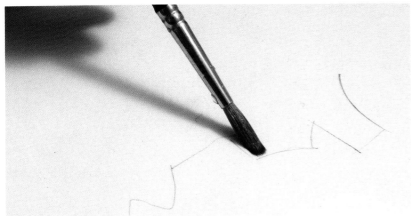

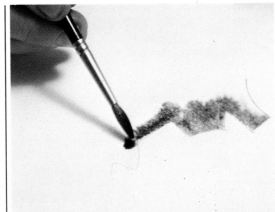

Laying a wash against a complicated edge. This is a very useful technique which is much simpler than it looks. It is especially useful where you want to achieve relatively flat colour within complex borders. Start by lightly drawing the outline you require with pencil. Then, using a sable brush, dampen the paper up to the edge (**above**).

Next using a loaded brush drift colour onto the damp paper, allowing the paint to suffuse the damp area and working it gently up to and around the drawn edge (**top right**).

When this stage has been accomplished work away from the line, applying paint more freely until the necessary area has been covered (**right**).

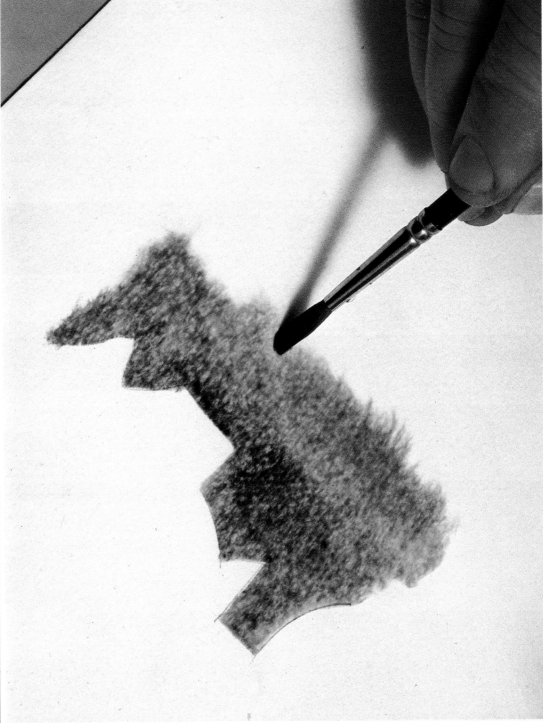

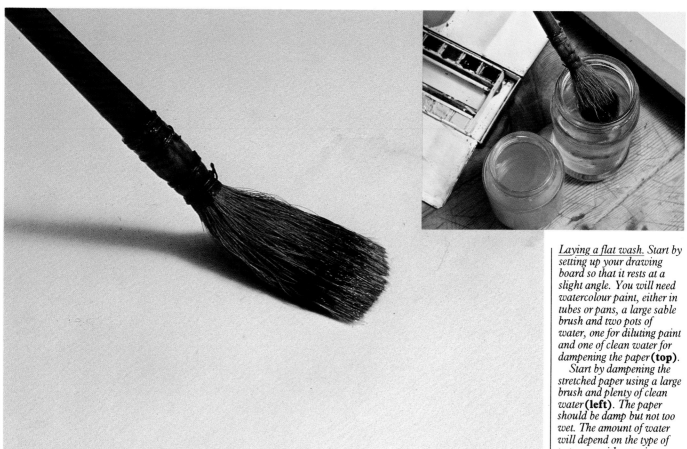

Laying a flat wash. Start by setting up your drawing board so that it rests at a slight angle. You will need watercolour paint, either in tubes or pans, a large sable brush and two pots of water, one for diluting paint and one of clean water for dampening the paper **(top)**.

Start by dampening the stretched paper using a large brush and plenty of clean water **(left)**. The paper should be damp but not too wet. The amount of water will depend on the type of paper — with experience you will learn to judge the correct amount of water.

Mix a dilute solution of colour in the lid of your paint box, or in a suitable container **(left)**. It is important to mix sufficient paint if you are to achieve an even tone.

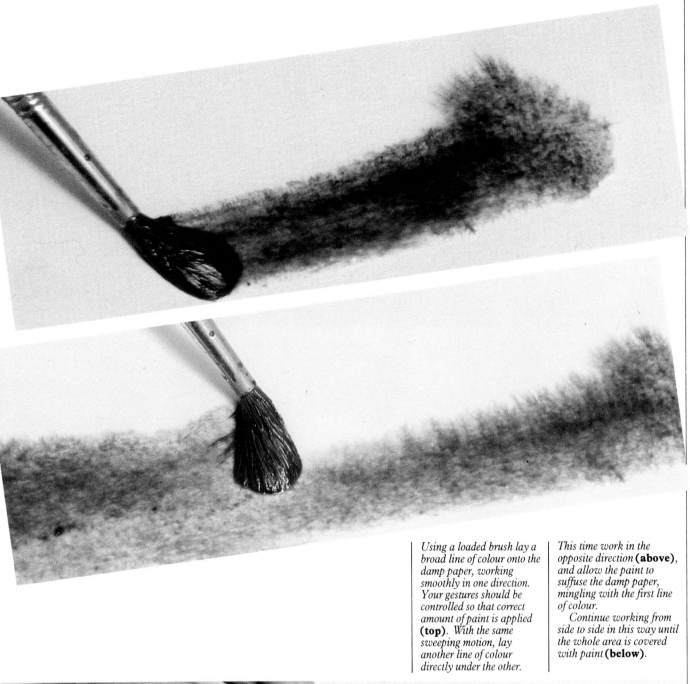

Using a loaded brush lay a broad line of colour onto the damp paper, working smoothly in one direction. Your gestures should be controlled so that correct amount of paint is applied **(top)**. With the same sweeping motion, lay another line of colour directly under the other.

This time work in the opposite direction **(above)**, and allow the paint to suffuse the damp paper, mingling with the first line of colour.

Continue working from side to side in this way until the whole area is covered with paint **(below)**.

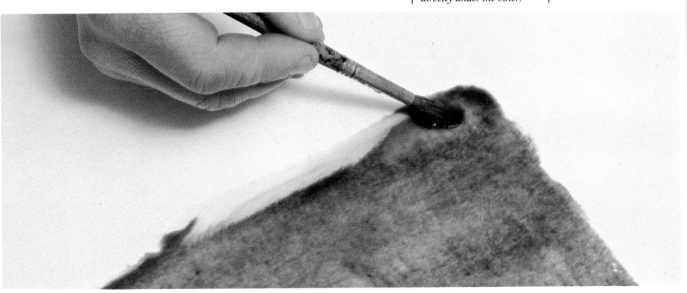

7

View from Mirabella by John Robert Cozens (1752--1797) **(right)**. *The two broad areas within the composition are given texture and variety by the subtle dispersal of blues and greys.*

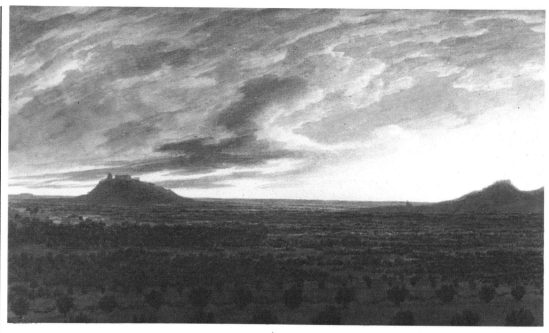

The Viaduct by John Sell Cotman (1782–1842) **(right)** *shows the artist's developed sense of graphic design and austere composition. He has used strong architectural forms in a landscape setting, making full use of the luminous tones and colours which only pure watercolour can provide. The picture is painted with a bold symmetry, and the warm colour of the stone bathed in light is clearly described against the more heavily shaded areas. The artist was expert at assessing tone, and he has conveyed this sense of grandeur and airiness with a very limited range of colour. There is very little real detail in the picture, and the sense of absolute reality has been achieved almost solely by uisng expanses of wash and planes of colour.*

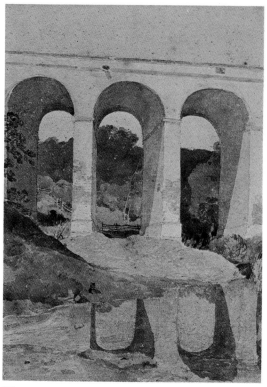

REPRESENTING LANDSCAPE

Although watercolour is one of the earliest artists' mediums known to man, it really came into its own in the eighteenth and nineteenth centuries, when it was developed by many European painters as a landscape medium. The upsurge took place mainly in England where John Cozens, John Constable, J M W Turner and many others became associated with what is often referred to as the 'English School'. They were not the first by any means, however, to realize the full potential of the medium. Two centuries earlier the German artist, Albrecht Durer, appreciated the qualities of the medium, how subtly

and efficiently it could render natural objects and atmosphere.

The classical method was to use the white paper to depict the lightest highlights, and make progressively darker tones by mixing in more paint. Although this was considered the purist approach to watercolour, the main exponents of the English school all used methods which varied from the accepted way of applying paint. Many of them used 'body colour', that is mixing white with colour instead of using the white tone of the paper. This practice was very much disapproved of by 'purists' because it made the paint opaque, like gouache, so losing its natural transparency. Watercolour has continued to be popular for landscape painting, and is one of the most common mediums of amateur artists as well as being used extensively in a professional capacity.

View in the Island of Elba by John Robert Cozens **(above)**, *he again uses a limited palette to achieve a sense of scale and drama in this rugged mountain scene. The dispersal of light and darker blues is delicately handled to depict both detail and atmosphere in a basically simple composition.*

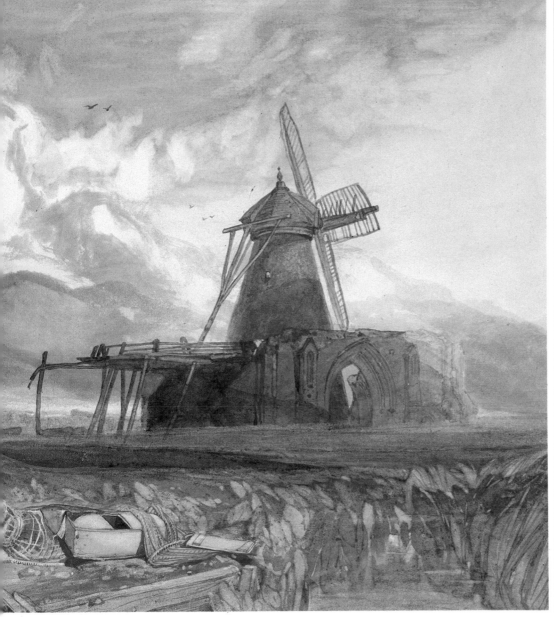

St Benet's Abbey, Norfolk, by John Sell Cotman **(left)**, *has an even greater sense of space due, mainly, to the large expanse of sky and hazy blue tones of the distant horizon. The foreground is emphasized in warm, earth colours. The blue used in the figures and the small area of water echoes the sky above and gives a feeling of complete unity and harmony to the whole scene.*

SEASCAPE WITH GOUACHE AND INKS

In this painting the artist has used gouache and water-based inks to produce an expressive and cool painting. The underpainting has been laid in with very bold colours — bright transparent inks which were allowed to bleed into one another. In this way it can be established quickly and because the inks dry fast the artist can start to lay in the basic structure of the painting almost immediately.

The traditional method of underpainting requires time-consuming layering of colour upon colour, the use of these boldly coloured inks expedites the painting process. The painter can proceed straight from the underpainting to developing the basic structure of the painting without having to wait for the previous coats to dry.

Gouache is an opaque, water-based paint with a tendency to be chalky. The translucent inks glow beneath the gouache giving life to its slightly chalky surface. It is however, a very flexible medium, which can be worked wet-into-wet, dry brushed or splattered and the artist here has exploited all these methods to good effect. Gradually the bold bright tones of the underpainting have been overlaid with cool greys mixed from Payne's grey and olive green and white. The orange ink lends a subtle hint of warmth to the masses of the land area, whilst the blues and green underlying the sea lend it a cool wintry atmosphere.

This subject obviously requires a 'cool' treatment but even a dominantly cool subject can be enhanced with a touch of warmth. The painting further illustrates the degree to which it is possible to mix unlikely media to good effect — at the end of the day the only rule is that the method should work and that the finished painting should be successful.

The artist has exploited the qualities of gouache to the full and with a subtle mixture of colour and tone he has created a painting which is evocative and atmospheric.

Using a large sable brush the artist lays down large areas of red, orange, blue and green ink, which correspond to the shape and colour tones of the subject **(right)**. *The bold colours of this underpainting will later be modified by opaque gouache.*

Here the inks are bleeding into each other **(left)**.

The artist chooses a palette of black, white, burnt umber, olive green, Payne's grey and Prussian blue gouache and mixes a variety of grey tones from the white, Payne's grey and olive green. He blocks in the shape of the pier while the ink is still wet and then allows the paint and the ink to bleed **(below)**. With a finer brush he begins to dot in the lighter tones of grey and white, again allowing the colours to bleed together **(bottom)**.

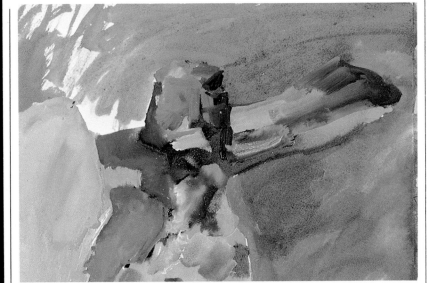

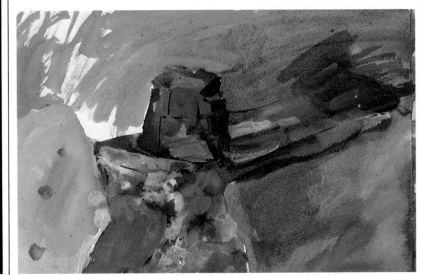

11

He covers the orange coloured underpainting of the foreground with a thin wash of burnt umber **(right)** and adds a touch of olive green to the mixture of white, Payne's grey and green, and with the larger brush covers the sea and sky areas with broad, loose strokes **(below)**.

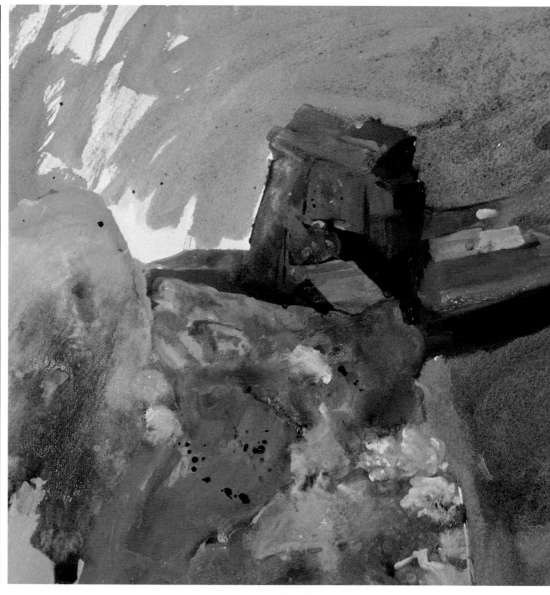

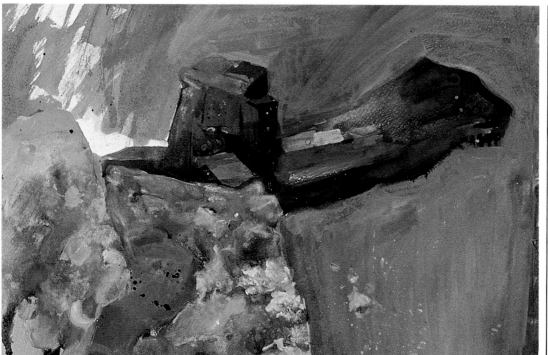

The remaining sky area is covered in this same colour and allowed to dry. Using pure white gouache he blocks in the white shape on the left, and adds small touches of white to the foreground **(above right)**. More olive green is added to the mixture and loose strokes of colour are worked into the sea and foreground rocks. He loads a brush with pure white and splatters onto selected areas **(right)**. Using the same pure white he puts in the line on the side of the pier and other details **(far right)**.

The artist puts in small
details with a fine sable
brush and black paint
(**above**). *The final picture
is an evocative and
atmospheric painting, far
removed from the bright
spontaneous beginnings of
the ink underpainting.*

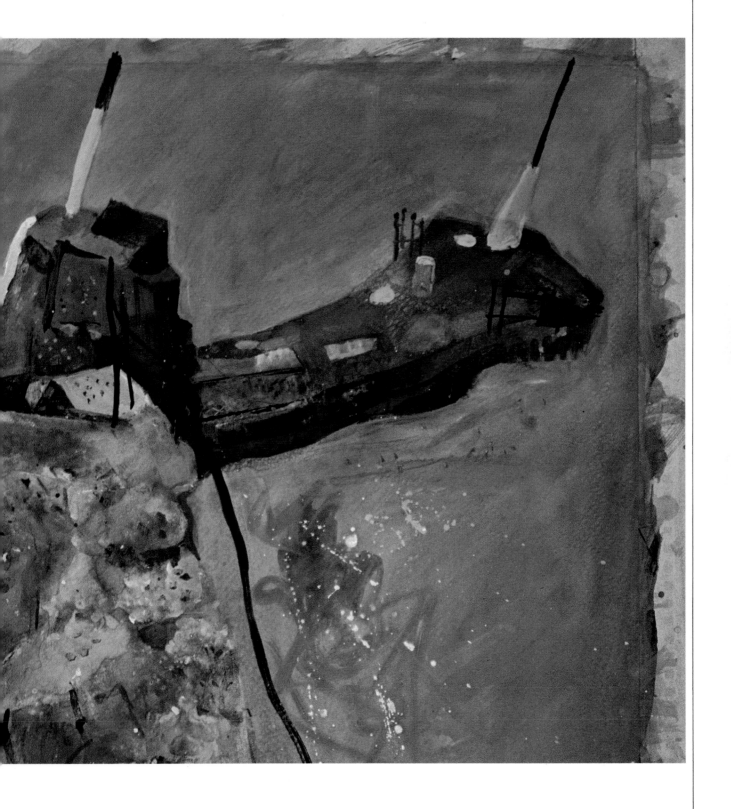

TUSCAN LANDSCAPE

One of your first decisions when starting a watercolour will be the texture and quality of paper you use, for this will affect the way you apply your washes. An even wash is easier to achieve on a very rough surface, for example, if the paper is fairly damp.

The watercolourist, who is seeking to keep the painting as translucent as possible, works from light to dark and it is clearly important to make an early decision about the areas to be left absolutely white. If there are none at all then the colour closest in tone to white is established and this is the first wash. Working from light to dark is fraught with difficulties — some of the palest areas may be small and complicated and these will have to be carefully avoided when the darker surrounding washes are applied. If the colour is to remain

*The artist worked from a landscape sketch made on holiday (**above**). He used several colours — Naples yellow, cadmium yellow, cobalt blue, raw umber, viridian green, light red, Payne's grey and indigo. Working on stretched paper, he laid a warm neutral coloured wash mixed from raw umber, cobalt blue and naples yellow (**left**). He darkened this as necessary by applying a second coat when the first coat had dried (**below**).*

transparent it is not possible to lighten them again. This problem is inherent in the 'purist' use of watercolour which demands that as few corrections as possible are made.

Many watercolourists use body colour — watercolour mixed with white — as a way of making dark colours light again, and correcting mistakes. The translucency prized by the purists is sacrificed but a greater freedom is gained. Without the use of body colour the only way of making dark areas light is to remove the paint. This can be done by wetting the area and blotting the colour off with a tissue, or lifting it off with a brush. Some artists scrape it off with a knife but this is only possible if the paper is thick and strong.

He laid the sky area in the same way, using a wash of cobalt blue. The complicated shape **(centre)** was made by wetting the paper up to the required line. He worked the paint into the damp area, letting it spread to the edges of the shape. He blotted the sky with blotting paper **(left)** to give it a pale, even texture.

He then worked a pale solution of sap green over the foreground area **(below)**. These overlapping washes gradually built up to create a grainy, subtly modulated area of colour in the foreground.

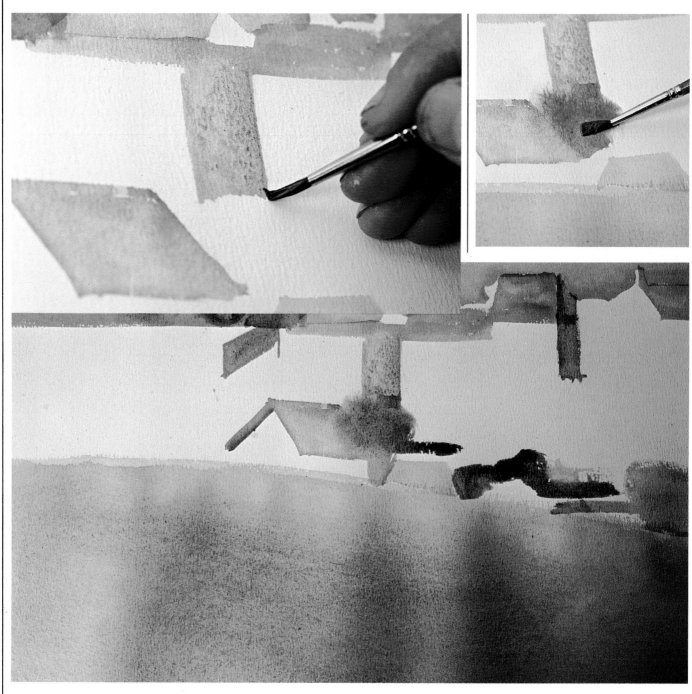

He painted the buildings using washes of light reds and greys **(top)**, treating them as simple shapes. Without wetting the paper first, he put in the trees as small shapes of indigo and viridian **(top right** and **centre)**.

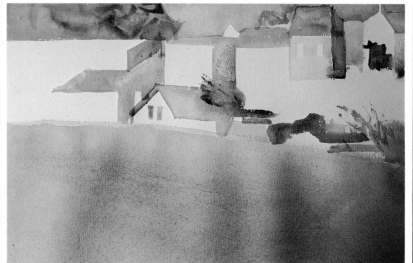

He continued to develop the cluster of houses, using the same colours **(above** and **left)**, allowing each area to dry before working into it. Notice the feathered effects in the middle distance.

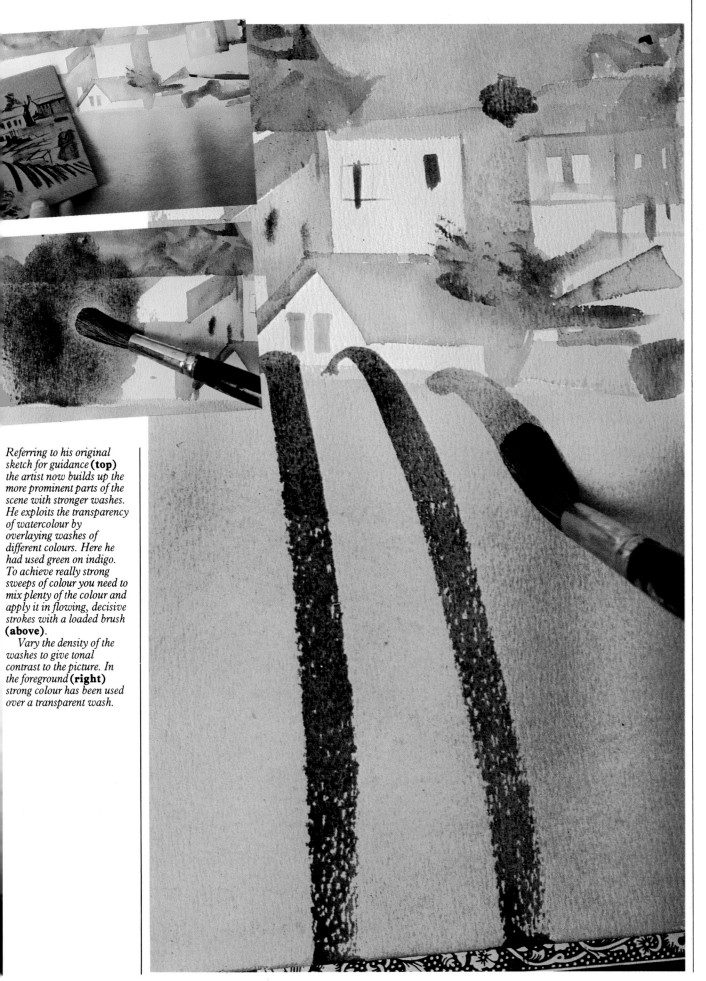

Referring to his original sketch for guidance **(top)** the artist now builds up the more prominent parts of the scene with stronger washes. He exploits the transparency of watercolour by overlaying washes of different colours. Here he had used green on indigo. To achieve really strong sweeps of colour you need to mix plenty of the colour and apply it in flowing, decisive strokes with a loaded brush **(above)**.

Vary the density of the washes to give tonal contrast to the picture. In the foreground **(right)** strong colour has been used over a transparent wash.

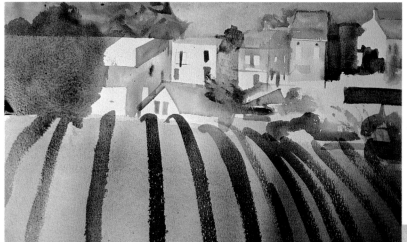

The image emerges very quickly, the separate areas of colour coalescing in the eye of the viewer to create the image. It is not necessary to work in a tight detailed way and watercolour, which is a very flexible medium, can be used to create exciting, atmospheric images when handled loosely and impressionistically **(left)**.

The stronger colours can be built up until they are quite dark and intense **(below)**. Here the artist has laid several stripes of green one over another so that the bands of colour which represent the rows of vines are quite intense.

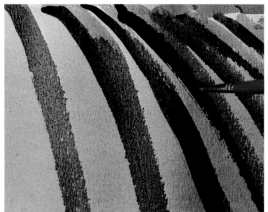

By using positive colours in the foreground, and less defined tone and colour in the background, it is possible to establish a sense of space and distance in a picture **(right)**. This technique is known as aerial perspective.

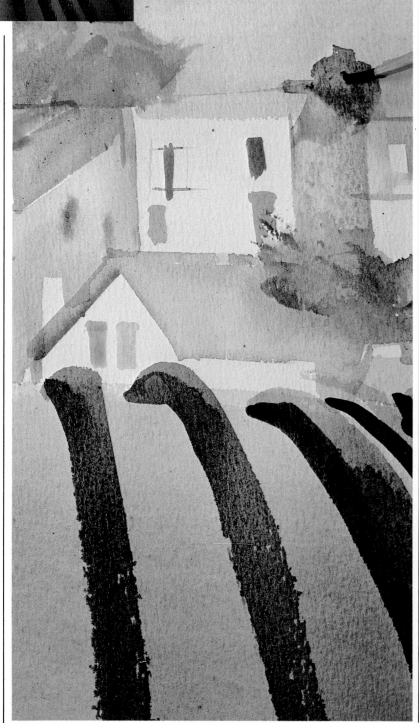

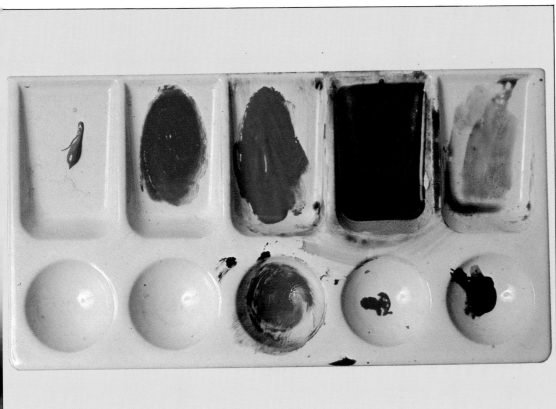

Watercolour washes are difficult to control on the palette, and colours often run into each other. You may find it easier to squeeze out only one or two colours at a time. The type of palette used here is particularly useful for watercolour as it provides the artist with a place for laying out the colour and several deep troughs for mixing washes **(left)**. *Do not be tempted to overwork your picture. Watercolour is a very subtle medium and a painting is easily ruined. As it nears completion, study it carefully and decide if any adjustments are necessary. Avoid the temptation to fiddle with the paint. Here the artist added a bright yellow wash to create a splash of warmth and brightness* **(below)**.

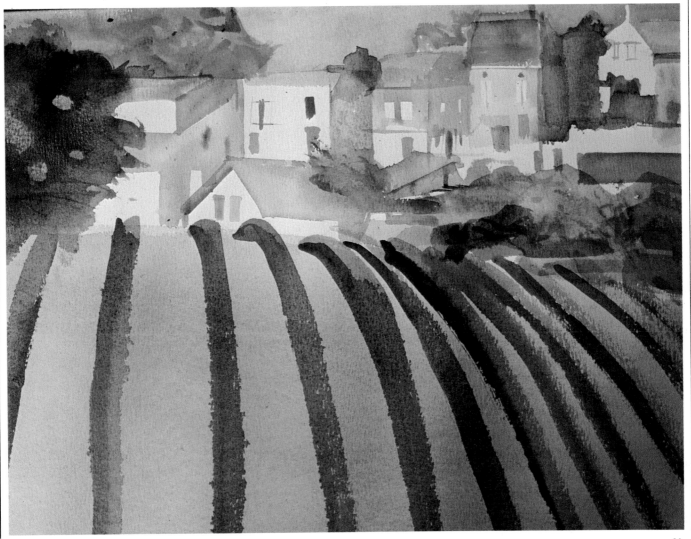

TREES BY WATER

Gouache paint is entirely different in weight and feel from watercolour. If you have never used the medium before you should first experiment by making marks with an assortment of brushes. The paint can be used in several consistencies to create a range of washes, areas of flat colour and thick impasto. Many of these effects cannot be achieved with pure watercolour. Unexpected things can happen as gouache dries — the colours tend to lighten and thicker patches will dry to a different tone than thinner areas. The paint is best used directly and freshly, for tickling wet paint onto dry causes patchiness and unnecessary reworking can spoil the texture of the paint.

Gouache can be used to lay in flat washes in the same way as watercolour, and there are also several ways of laying one colour over the other. Paintings are often begun with a flat mid-tone laid as a wash. This allows the artist to exploit the flexibility of gouache — that is to develop the image towards both the darks and the lights. Paint can be scumbled across the base colour to create a diffused effect. Solid colour can be worked into flat or variegated washes while they are still wet. The edges of the flat area will merge into the wash once the paint dries.

In this painting the artist has created an effective and lively image using only one brush and a limited

range of colours. He has managed to create a rich variety of greens, and by careful observation has captured the intrinsic qualities of the foliage, the water reflections and the sky. Notice how the colours diminish in intensity towards the horizon.

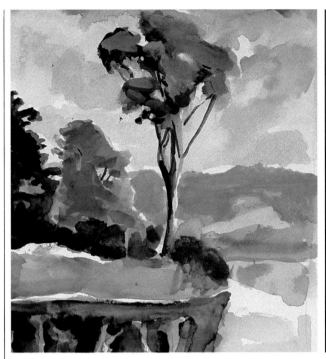

The artist paints in the soft shapes of the trees, sky and water using thin washes of blue and green, adding white to vary the tone **(opposite)**. *He then works into these colours with darker tones to establish the basic forms and give an impression of distance* **(far left)**. *Using undiluted paint, he overpaints the forms in detail, varying the green hues by adding touches of yellow or red. He intensifies the colours in the reflections on the water* **(bottom left)**. *He mixes brown from scarlet and black, and lays in the trunk and branches of the tree. He extends the shape of the tree, working with small dabs of red, green and orange* **(left)**. *He then paints the background reflections and adds horizontal stripes of blended colour to the water surface* **(below)**.

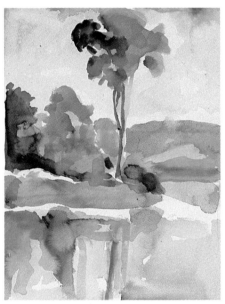

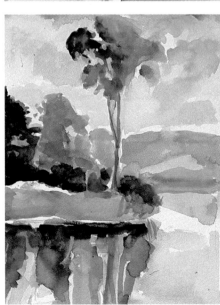

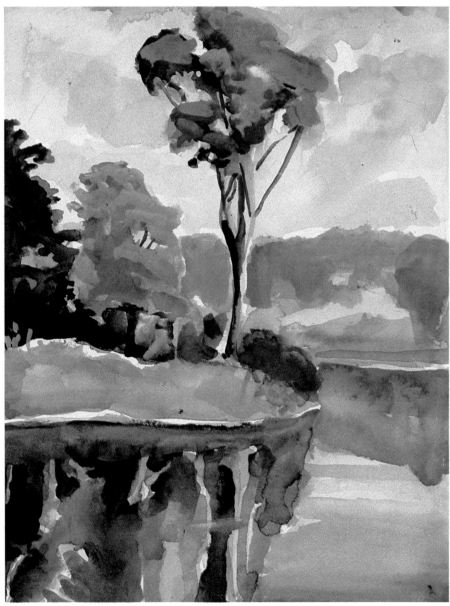

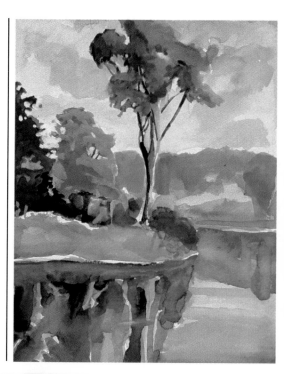

Gouache is thick and opaque and it is important not to overmix the colours. The artist dilutes the paint with a lot of water and lays in the colour in thin washes **(below)**. Different effects can be achieved by working wet into wet or, alternatively, by allowing the underpainting to partially dry before applying the final wash.

Complete the painting by heightening the tones with small patches of thin paint over the sky and trees. Mix white into the colours to vary the tones **(right)**. The actual colours in the picture are limited, but a variety of tones has been created by a careful use of white paint; the translucent quality is the result of patient application of overlapping washes of pure colour.

TREES AND HILLS

There are many ways in which an artist can create the illusion of space in a painting. Linear perspective and the overlapping of objects are useful devices, and aerial or atmospheric perspective is another. In this method the illusion of distance is created by painting those objects closest to the viewer in their full tonal and colour values. Thus surfaces facing a light source will be light and bright, whilst those turned away from the light source will be dark. Objects farther away will show less of a contrast and will take on a bluish tinge. The artist has used many of these techniques to create an illusion of space — the tree in the foreground is painted sharply and clearly with strong contrasts of light and dark while those in the distance are less clearly defined.

Warm and cool colours also have their part to play. Colour temperature is subjective and people vary in their ability to perceive colours in these terms. The warm colours are the reds, yellows and related colours and in general these tend to come forward. The cooler colours, the blues, purples and some greens tend to recede. Thus if there is a red object in your painting it should be rendered with bright cadmium red if it is near the picture plane, but with burnt sienna if it is farther away.

The artist works from a simple sketch (bottom). He uses a large sheet of heavy watercolour paper which he had previously stretched. He mixes a large quantity of cobalt blue and Payne's grey (below) and using a large sable brush starts to lay in a series of overlapping washes (below left).

He starts with the sky,

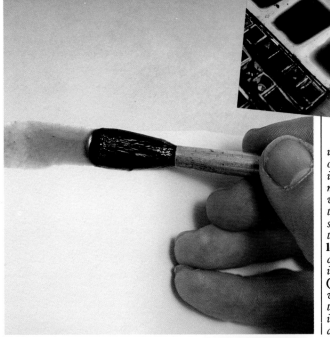

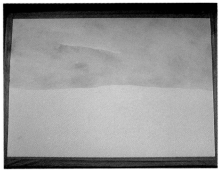

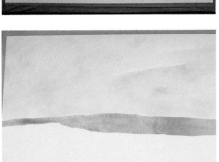

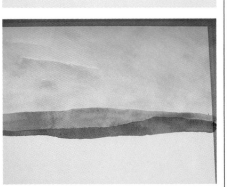

using a very dilute solution of the colour which he lays in with broad sweeping motions of the brush, working from side to side of the paper, allowing scumbled areas to stand for thin, misty clouds (top, far left). He allows this to dry and then continues to lay in increasingly intense washes (far left) allowing each wash to dry before applying the next. Sap green is introduced in the middle distance.

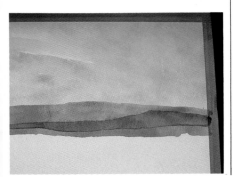

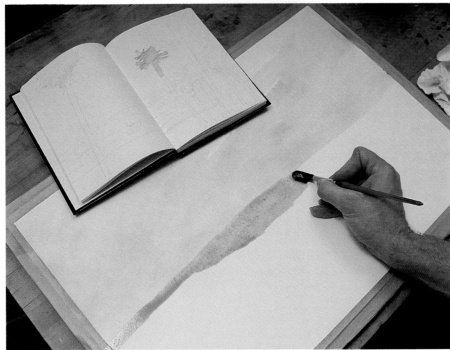

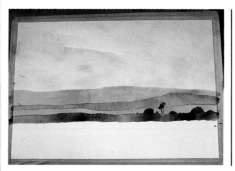

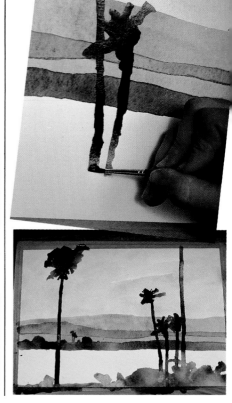

Using sap green mixed with Payne's grey the artist develops the middle distance using a small brush (**left**). Then with a darker mixture he develops the foreground area — the trees and shrubs — with a fine sable brush. He does not scrub in the paint, but moves it over the surface so that it dries with a clearly defined edge (**right, below** and **bottom**).

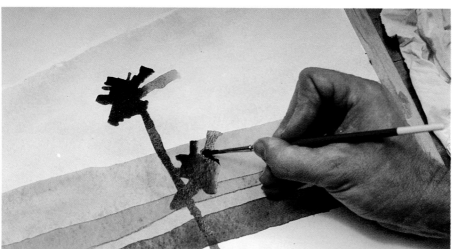

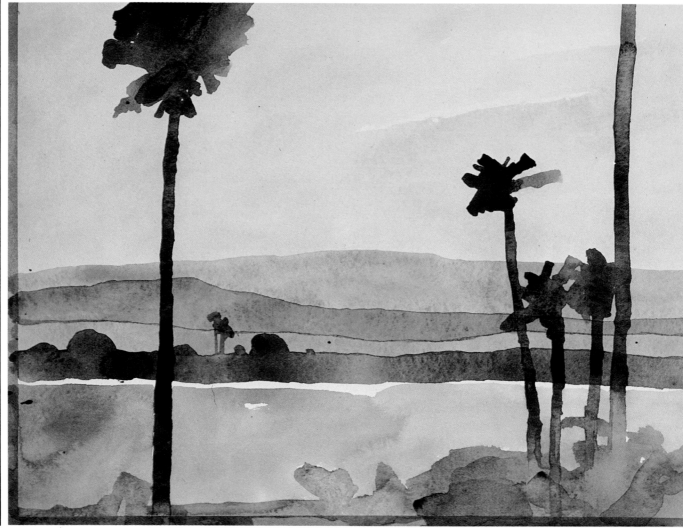

ELM TREES

In the painting on this and the next pages the artist has exploited a variety of watercolour techniques to create a convincing and pleasing landscape in which the feeling of distance and recession has been successfully established. The artist started by laying in a wash of Prussian blue **(below)** to create the sky. The wash was laid unevenly, different intensities of colour and areas of white paper working to create the impression of a cloudy sky. Later, he has used several dry brush effects to create the details of the trees, their branches and the foliage of the ivy. A small No 6 brush was used for drawing in details. The brush was loaded with paint and the excess was then wiped off with a cloth. The fibres were brought to a point so that very fine details could be rendered.

The artist maintains the coherence of the landscape by subtly linking the colours in the different areas of the painting. He has used the same blue for the linear detail in the middle distance, on the ploughed field, and in the shade of the ivy on the trees. He has balanced the warm and cool tones. In the foreground, for example, he has used a warm brown wash in the middle distance while a colder yellow is used to depict the cultivated fields beyond. In the ivy warm reddish-brown and blue are used to deepen the intensity of the green washes.

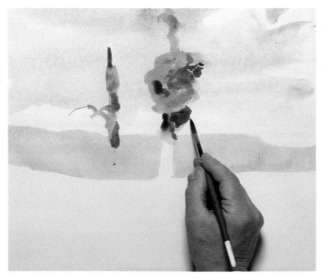

Using viridian, emerald green and burnt umber he applies the basic forms of the trees **(left)**. He uses the fine point of a sable brush to draw the finer details of the branches and the ivy which clings to the tree **(below)**. He darkens the burnt umber areas with a little blue, and mixes yellow into the green.

The artist wets the paper with a large brush and applies a thin layer of Prussian blue to the sky area **(previous page)**. He brushes in a yellow ochre wash across the centre of the paper, leaving white spaces along the horizon and in areas where the main forms are to be placed **(below)**.

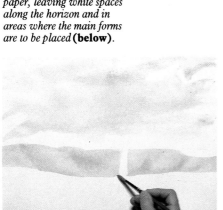

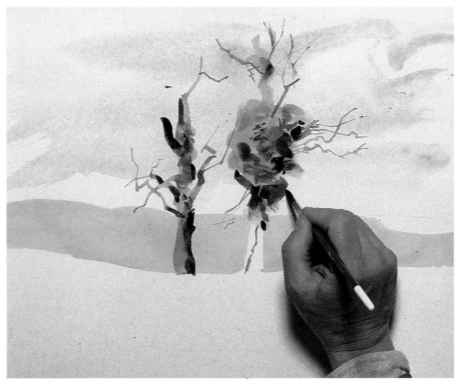

The artist continues to extend the forms and intensify the colours. By fanning out the bristles of the brush between thumb and forefinger he is able to obtain a feathery texture using a dry brush technique **(right** and **far right)**.

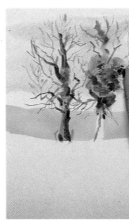

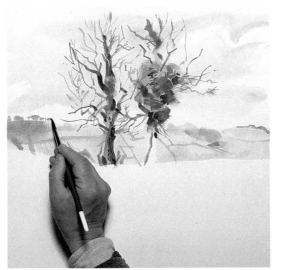

Next the artist dampens the yellow ochre wash with clean water and draws into it with a mixture of Payne's grey and blue **(far left)**. He adds detail to the grey area with ultramarine, keeping the paint thin and wet. He uses the same blue in the foliage shadows and uses a warm reddish brown to contrast with this. He mixes Payne's grey and burnt umber and lays a broad streak of colour across the foreground **(left)**. He trims the paper to obtain the final picture **(below)**.

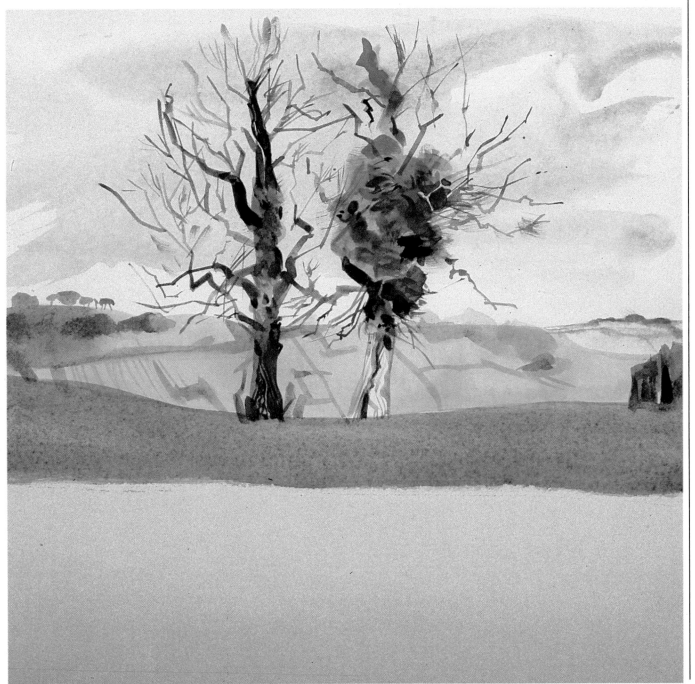

GARDEN WITH FLOWERS

The watercolour landscape on this and the following pages has been created using very fluid washes of transparent colour — the traditional watercolour technique. Watercolour is a difficult medium to handle and only with experience will you really know what will happen when you make certain marks or apply paint in a certain way. Before you start on a painting such as this, experiment with different marks on scraps of similar paper — you will find out how absorbent the paper is and how its texture will affect the finished work. Start your painting by laying in thin, broad washes of pale colour, leaving patches of white paper to serve as the highlight areas. Remember that a large, wet pool of colour will dry with a graduated tone and a strong irregular outline. By overlaying a succession of washes you can produce vivid colours, a patterned network of light and dark tones, and linear detail, which suggests the texture of foliage and flowers.

For this particular painting the artist used only one size of brush — a good quality, no 6 round sable. With hairs loose, or spread, the brush can be used to lay in broad sweeps of watery colour. Bring the hairs to a tip to create fine details. You can speed up the drying process by using a hair drier but as this tends to deaden the colour you may prefer to let the paint dry naturally. Some artists, however, exploit the fact that, dried artificially in this way, the paint acquires very marked contours which can be incorporated into the painting. By holding the paper horizontally and tipping it to make the fluid paint run where you want it to you can control and use the edges of the colour as drawn lines.

It is difficult to correct mistakes made in watercolour, but not impossible. In fact, if you use good quality paper you can wash off all the colour by laying the paper in a bath of water. The colour will float off and you can dry the paper stretched on board. Areas of colour can be lightened by gently lifting excess colour from the surface with fine grained sandpaper. Marks can also be scratched from the surface with a scalpel blade. Be gentle, for the texture of watercolour paper is important to the finished look of the painting and any kind of erasing will alter or damage the paper surface.

Blotting paper can also be used to control the paint — it can be dipped into very fluid paint to soak up excess moisture and can also be used to control the edges of the pools of colour.

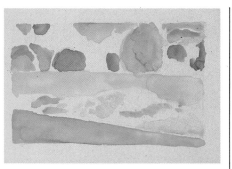
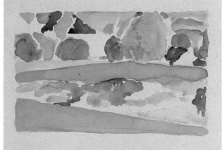
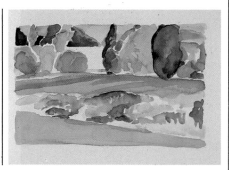

The artist sketches out the composition very lightly with a fairly hard pencil and lays washes of thin wet paint to establish basic forms and local colours. He lets the painting dry and then applies layers of denser colour, gradually building up the forms and local colours (**above**). *He lets the painting dry and then applies layers of denser colour, gradually building up the forms with thin, overlaid washes* (**top centre**). *He paints in the shadow shapes, and works into the trees with overlapping areas of colour which define the form* (**top right**).

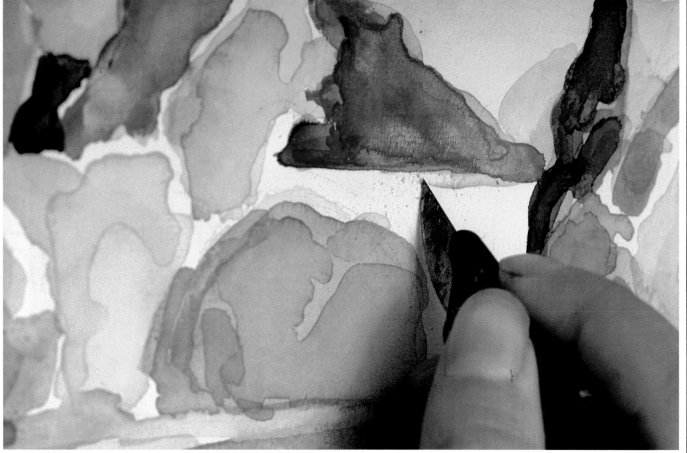

Corrections can be made by scratching off splashes with a blade and lightly sandpapering the surface with a fine sandpaper (**centre**). *The artist uses a sharp blade or scalpel to remove unwanted areas of colour* (**above**).

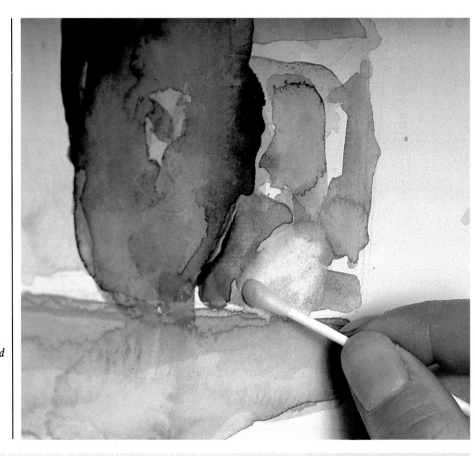

To lighten a tone or to stop the paint from bleeding, a cotton wool stick can be used to blot up excess moisture or colour **(right)**.

The painting is completed by strengthening the dark tones in the background with Prussian blue and black. He lays a broad wash of yellow over the grass to lift the tone **(below)**.

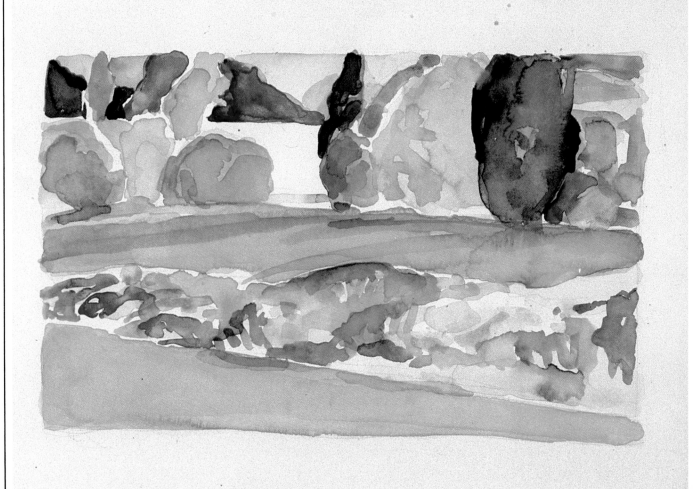

LANDSCAPES IN OIL

Portable materials are crucial to the landscape painter, and these have changed remarkably little since the days of Joseph William Mallord Turner (1775–1851). In his paintbox **(below)** we see some of the equipment and materials used by this great English landscape artist. Powdered pigments were kept in glass bottles with cork stoppers; prepared paint was stored in the small bladders at the back of the box. These containers were not, however, very reliable and were replaced in the 1840s by the metal tubes we use today. Turner seems to have used fairly large bristle brushes.

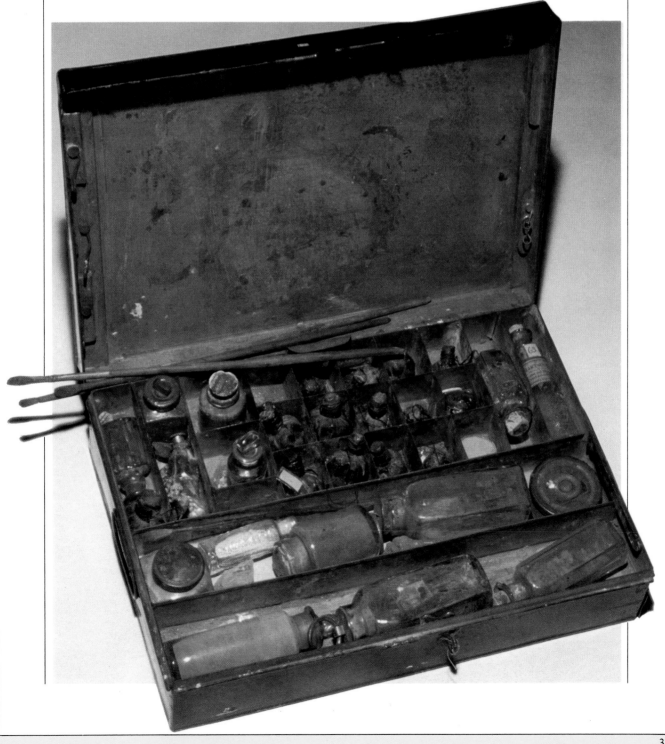

CHOOSING A PAINTING KIT

Artist's suppliers are places of temptation for the novice and the established artist alike and a fascinating range of products are usually on display, all aimed at enticing you to part with your money.

Painting materials can be bought as made up kits. The boxes in which the paints are supplied vary from very simple carrying cases to large, elaborate chests with drawers, fold-out trays and other refinements. At the top end of the range there are splendid constructions far beyond the average, or even the fairly affluent, pocket.

If you are a newcomer to oil painting you may decide to buy a kit and save yourself the trouble of selecting your own materials. However, it is usually an expensive way to buy equipment and you would be advised to consider buying an empty box and assembling the components yourself. You can then add to your collection as and when finances, and inclination, dictate. To help you assemble your equipment we have produced a list of basic materials.

The most important colour is white and you will need a large tube of this. There are three main whites in oil painting: flake white, titanium white and zinc white. Titanium is probably the most useful for the beginner — it is easy to work and mixes well with other colours; cadmium yellow is a strong permanent yellow; yellow ochre is a useful earth colour with a yellowish tinge; burnt sienna is an earth colour with a carmine tint useful for rendering light and shade; burnt umber is a heavy, opaque colour useful for painting shadows and darkening all colours; cadmium red is a good red somewhere between scarlet and crimson; alizarin is a transparent red with strong tinting power; viridian is a cool, bright green and can be mixed with yellow to produce a range of warm, brilliant greens; terre verte is a dull, transparent green, very useful for underpainting or for achieving complementary effects with reds; French ultramarine has strong tinting powers, and is the nearest pigment to the primary blue in the colour circle; and Prussian blue is very useful for producing glazes. These ten colours should — together with white — meet almost any need.

Some white spirit is essential to clean your brushes and some turpentine for diluting the paint. Linseed oil changes the consistency of the oil paint and makes it easier to move around on the support. It dries slowly and produces a glossy finish, unlike turpentine which produces a matt finish.

You will also need a selection of brushes, a palette, dippers for holding oil and turpentine, a palette knife for cleaning the palette and a painting knife for applying the paint.

With this selection of equipment plus a surface for painting on you are fully equipped to start painting your landscape.

Painting Kits. *Although usually an expensive way of buying materials, a kit can be useful for travelling or outdoor work. It is also a timesaving and easy way for a beginner to get acquainted with the basic materials. Kits come in many sizes, ranging from the very grand to the comparatively simple, but all of these contain the essential painting equipment — a selection of paints and brushes, a palette, turpentine and linseed oil. Many kits include a few supports to start work on.*

EASELS

For the landscape painter an easel is not a luxury but an essential working tool. It is also probably the single most expensive item to buy, so careful thought should therefore be given to the precise type of easel required. There are a number of different kinds, each suited to particular demands. For example, it is no good buying a large, solid easel if you work out of doors and need a portable type. Nor would it be advisable to choose a small, relatively inexpensive easel if you prefer to work on a large scale. Your choice must depend on your personal requirements.

The best easels are made of wood, usually a durable hardwood. If you have a proper studio, or a large room permanently set aside for painting, and if money is no particular object and you prefer doing large paintings, then a studio easel is ideal. This is extremely solid and will take a large, heavy canvas. However, it is bulky and not portable so you might need to supplement this with a lightweight easel.

Some painters do not like to stand while working — and detailed work can be very tiring even for those who do. In this case a traditional donkey easel, at which the artist sits down, could be the answer. Again, such an easel takes up a good deal of room and cannot be carried around or folded away.

Should the very large easels already mentioned prove impractical, the radial easel can be a good substitute. It gives firm support, is adjustable, and folds away when not in use. This portable easel is especially suitable for those who do not have a permanent room to paint in, or who occasionally like to work away from the studio.

Aluminium easels are cheaper than their wooden equivalents and can be a good way of limiting expenditure. Such lightweight easels are not always satisfactory, however, and you should not rush out and buy one without careful consideration. Your easel will probably be with you for life. It is worthwhile saving for the one you really want.

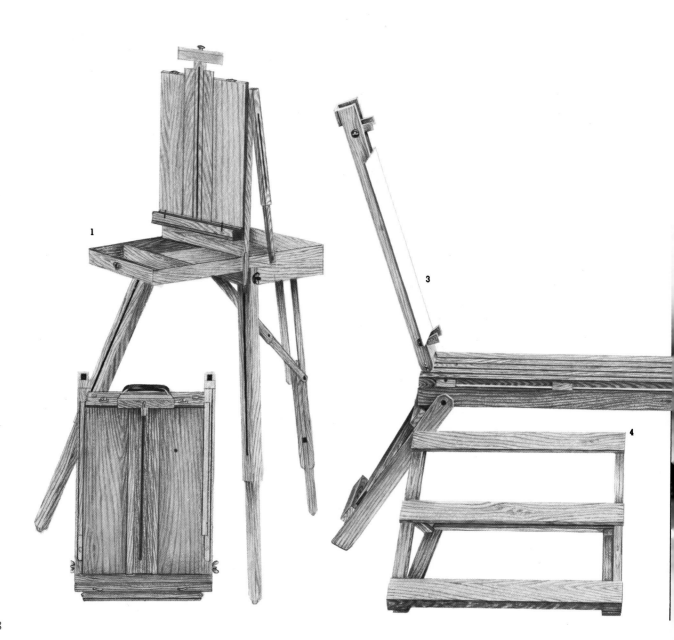

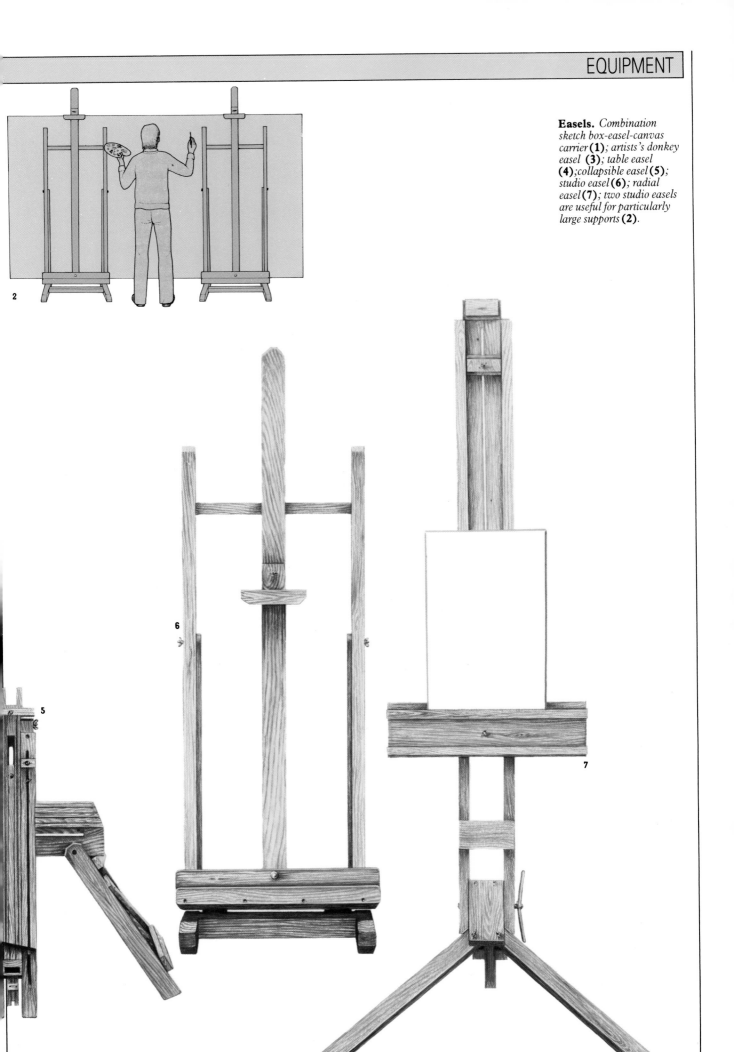

Easels. *Combination sketch box-easel-canvas carrier (**1**); artists's donkey easel (**3**); table easel (**4**); collapsible easel (**5**); studio easel (**6**); radial easel (**7**); two studio easels are useful for particularly large supports (**2**).*

Mountains Seen from L'Estaque is an example of Cezanne's (1839-1906) sustained study of landscape. As with many eighteenth and nineteenth century landscape oil sketches, this work was executed on paper. In this case the support may have been chosen for economy and portability — its large size and degree of finish suggest that he did not see it simply as a sketch. Cezanne bought the canvas ready-primed with a commercial ground. Prepared paper was sold both in standard canvas sizes and the different standard paper sizes.

Cezanne intentionally allowed the cream ground to show through among the colours in the painted layers, leaving it completely uncovered in places. There it reads as a colour in its own right — sometimes standing for highlights he intended to add later, sometimes representing a colour in the picture.

THE LANDSCAPES OF PAUL CEZANNE

Like Renoir, Cezanne exploited the contrasting effects of warm and cool colours in his painting. Where the warm cream ground shows through, it creates vibrant contrasts with the cool colours in the paint layer. Thus by juxtaposing cool opaque blues against the warm cream ground on the skyline, for example, Cezanne mutually enhances both colours. The cool blue appears even bluer and cooler; the cream ground appears as a warm pink against the cool blue.

Because warm colours advance and cool colours recede optically, they can be used to model form and to indicate depth and recession. Cezanne's limited palette means that subtly modulated mixtures and repeated usages of the same colour in different contexts gives an extraordinary harmony to the work.

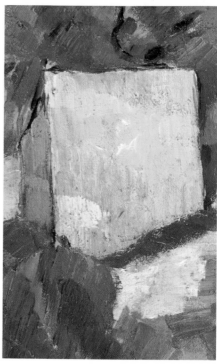

The cream ground is clearly visible here along the lines of the mountains, where it intensifies the cool blues of the sky and hills **(above)**. *The brushstrokes depicting background areas are equal in size to those used in the foreground. This method is contrary to the conventional approach in which varied brushstrokes are used to suggest depth and recession* **(top right)**. *Vertical, block-like strokes of colour help define the form of the buildings* **(right)**.

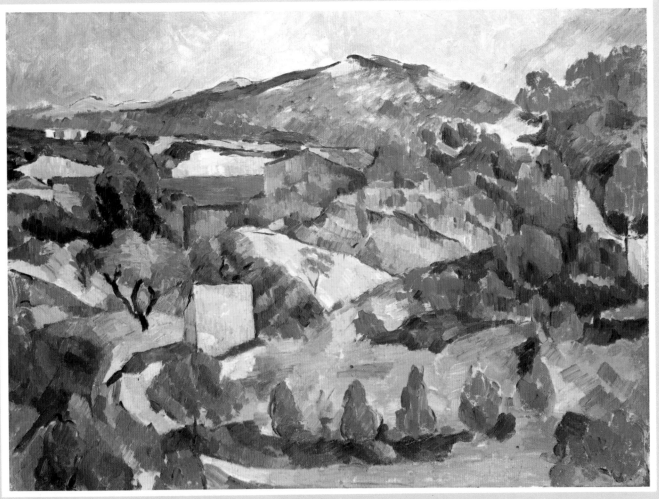

Cezanne's separate brushstrokes serve both to record his visual sensations of colour and to structure his composition. These touches vary according to the angle of planes and direction of forms. The trees in the foreground are depicted with curved strokes which suggest their characteristic form. Local colours are bright in the clear light, modified only by the warm sunlight and cool blue shadows.

ROCKY SEASCAPE

In this painting the artist has worked directly onto the canvas without any preliminary sketch or underdrawing. Paint was applied quickly in broad strokes of 'broken', unmixed colour instead of in flat colour areas. The painter worked 'alla prima' — applying the paint straight onto the canvas rather than layer by layer in the traditional manner — thus creating a feeling of spontaneity and immediacy.

Such a bold approach calls for a highly developed sense of colour and the knowledge of how individual colours react with each other. Experiment with bright, clear colours — here the artist has laid unnatural shades of purple, green and red over earth tones, so preserving the character of the subject whilst adding variety and individuality to the painting. Seen from a distance, however, the vivid flashes of colour resolve themselves to form a sparkling and lively seascape bright with light.

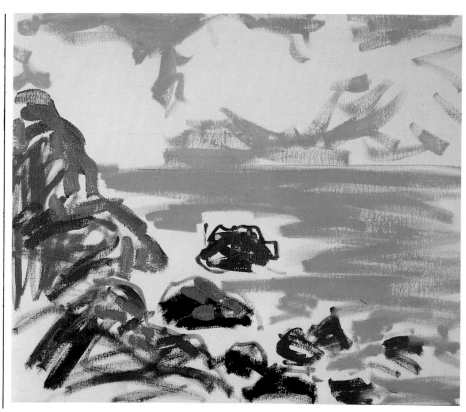

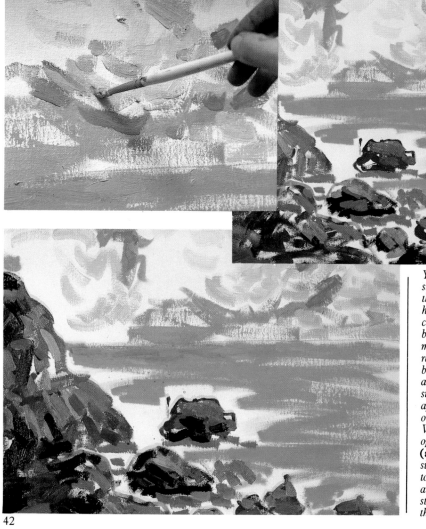

You will need a selection of strong, bright colours for this exercise — the artist here used cadmium red, cadmium yellow, cobalt blue, French ultramarine, magenta, Prussian blue, raw sienna, raw umber, burnt umber, yellow ochre and white. Sketch in the subject with charcoal, and apply a thin colour wash over the main areas (**top**). Work into these using thick, opaque strokes of colour (**above left**). Use burnt sienna and cadmium yellow to develop the roughed-in areas with the same short strokes. Use the direction of the brushstrokes to define the shapes (**above centre**).

Put thick strokes of paint on the rocks, allowing the previous layers to show through (**above right**). Build up the dark tones with Prussian blue and burnt umber, and brighten the 'lighter' dark tones with green. Add touches of cadmium red to highlight areas (**left**).

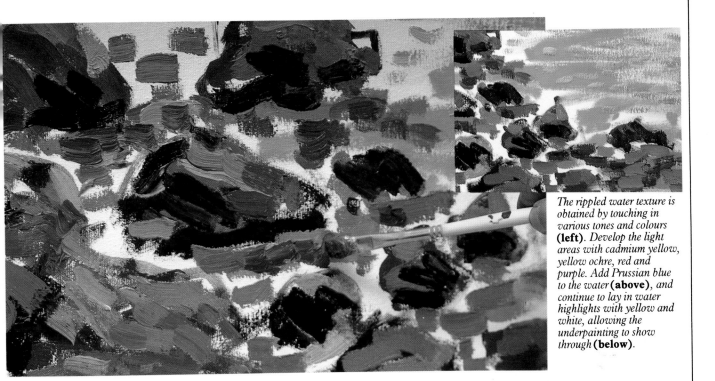

The rippled water texture is obtained by touching in various tones and colours **(left)**. Develop the light areas with cadmium yellow, yellow ochre, red and purple. Add Prussian blue to the water **(above)**, and continue to lay in water highlights with yellow and white, allowing the underpainting to show through **(below)**.

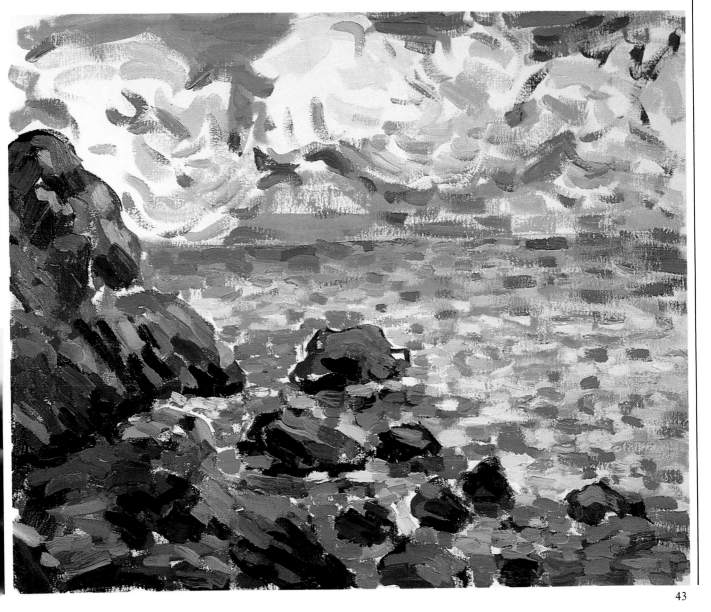

RIVERSIDE HOUSE

The secret of this painting lies in the way in which the artist has treated the water as an inverted image of the subject. The reflections are treated positively — laid down strongly and precisely in positive colours. All the mirrored points of the reflections lie vertically under the things reflected, and the vanishing points of the image correspond to those of the reflection. Mirrored perspective in landscape is easy to master since the reflecting water is always horizontal. Strong horizontal strokes will help establish the surface of the water; vertical strokes will convey the impression of the reflections.

Do not be confused or overawed by the prospect of painting reflections. Follow the basic rules and approach the subject with confidence, then paint what you see. There is no substitute for close observation.

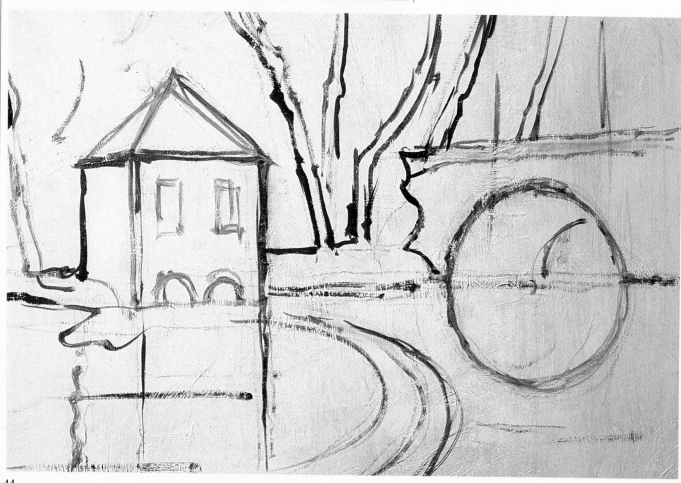

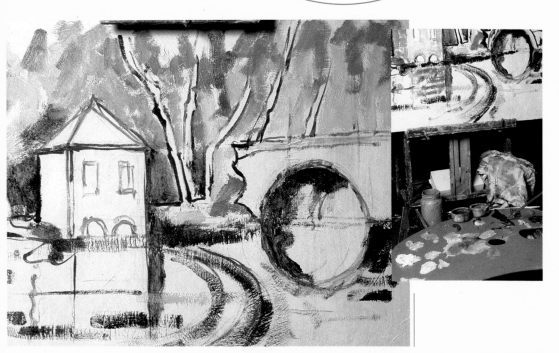

Lightly sketch in the outline of the subject with charcoal, using this as a guide for the black underpainting **(opposite)**. When you have established the main layout of the composition begin to loosely block in the colour, using yellow ochre, sap green and white for the background tree foliage **(left)**. Use short, directional brushstrokes to indicate form **(below)**. Here the artist is using a large flat bristle brush to indicate the perspective of the gable end of the house — the brushstrokes indicate the direction of the vanishing point.

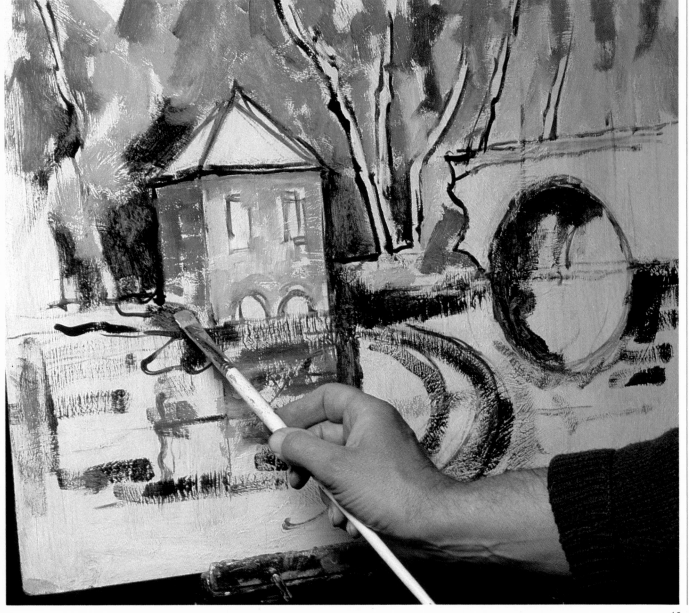

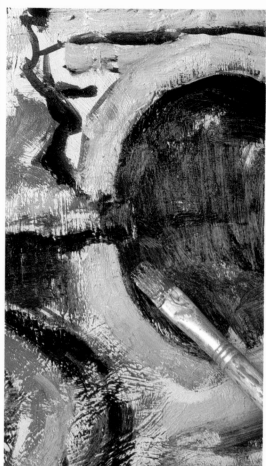

Apply the colour quickly with a large brush during these main blocking-in stages. The more rapid and spontaneous your brushstrokes, the livelier your painting will be. Keep the paint thin enough to be worked over as the painting progresses **(far left)**. By developing tonal ranges of a limited number of colours **(left)** you will ensure a subtle and harmonious theme in the basic blocked-in colour **(below)**.

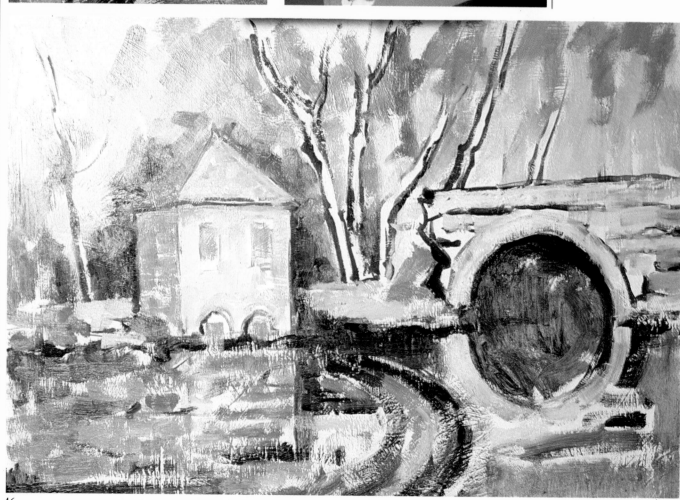

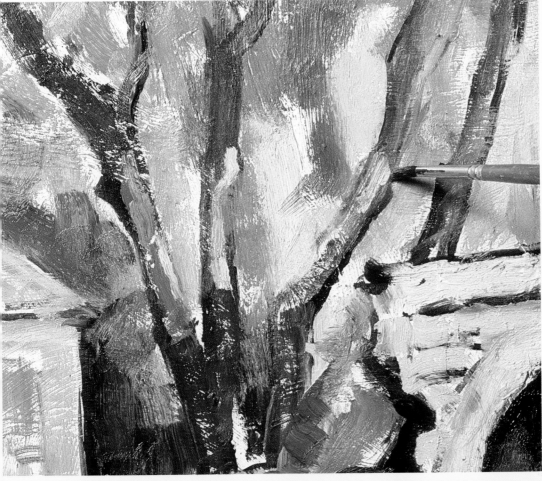

*Keep the tree fresh and crisp by redefining the outlines of the trunks and branches in a darker colour (**left**). Use the edge of a small flat bristle brush and black paint in confident linear strokes.*

*Add touches of pale yellow where the light falls on the tree trunks and branches (**below**). This lightening establishes the rounded form of the wood, helping the trees to stand out from the undefined background greenery.*

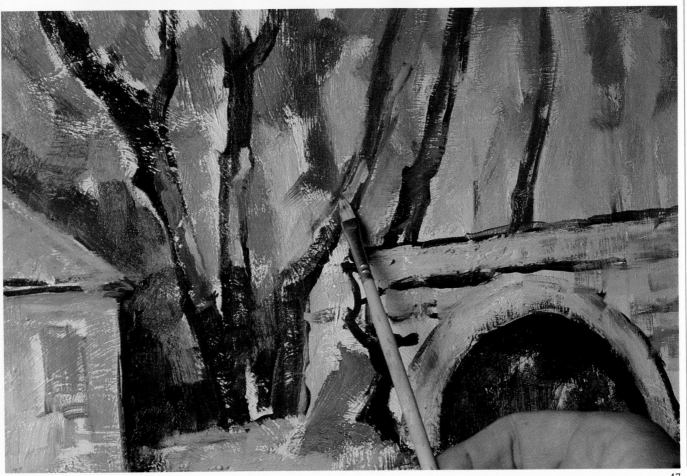

47

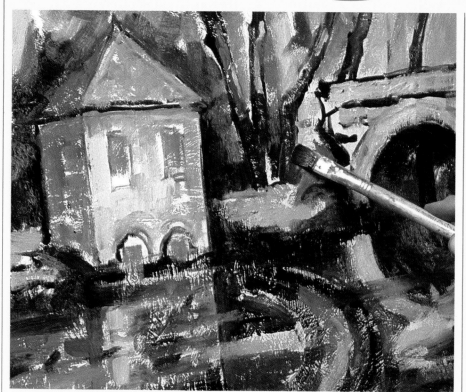

Continue to develop the trees by darkening the spaces between the trunks just above ground level **(left)**. *This increased depth of tone will give the impression of distance as well as widening the range of tonal contrast in the picture* **(below)**.

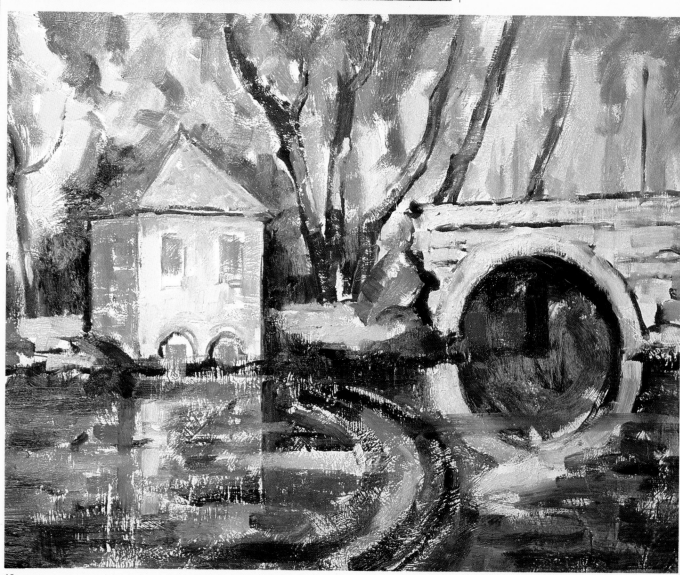

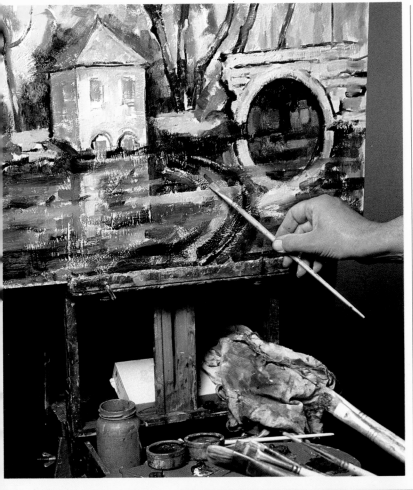

Make sure the reflections are as positive and well-defined as the rest of the picture. As you develop the tones and shapes of the landscape, try to strengthen the reflected images in the water to match these **(left)**. By standing back from the finished painting **(below)** and looking at it through half-closed eyes it should be possible to pick out the clear, slightly broken water surface with discernible reflected images.

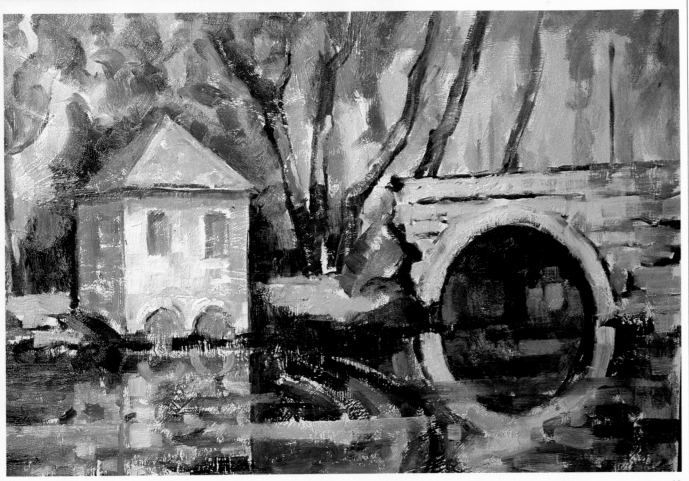

SUNSET ON THE WATER

This vibrant painting was executed with an extremely limited palette — alizarin crimson, cadmium red medium, cadmium yellow medium, cerulean blue and viridian. The artist used these five basic colours with white, mixing them as little as possible in order to keep the pigments pure and bright.

The method of working is clear from the step-by-step photographs here. The artist selected a colour, applied a few touches, and with the same colour moved on to another part of the painting. For instance, the sky colour is used not only for the sky, but in the trees and water as well. Similarly, the deep purple used in the underpainting is repeated throughout the whole painting in various shades and tones.

This is an extremely efficient way of painting as it saves the artist from having to mix and match colours each time they are needed. More important, this method gives the picture unity because each colour becomes a theme which runs throughout the whole image. Small and insignificant as one brushstroke may seem, it is impossible to put down a touch of colour without it affecting every other colour.

Whether painting or drawing, few artists choose to work on a picture as a group of individual and independent parts. Very rarely will a painter begin in one corner and work across the picture, or complete a section without regard for the rest of the picture. There is sound reasoning behind this. Painting has a natural rhythm which involves constant checking and rechecking of the work. This applies not just in one area, but in all areas simultaneously.

Lightly sketch the subject with charcoal, and block in the general colour areas in tones of green, violet and yellow **(bottom left)**. *Use cerulean blue and white to put in the water and tree highlights. Try to keep the whole image at the same stage of development and to work the colours simultaneously across the entire picture area. Apply the paint in short, directional strokes of pure colour* **(below)** *allowing these to mix optically — in the eye — instead of pre-mixing them on the palette.*

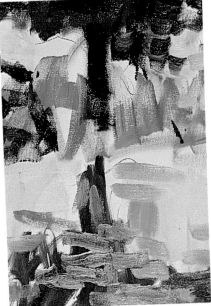

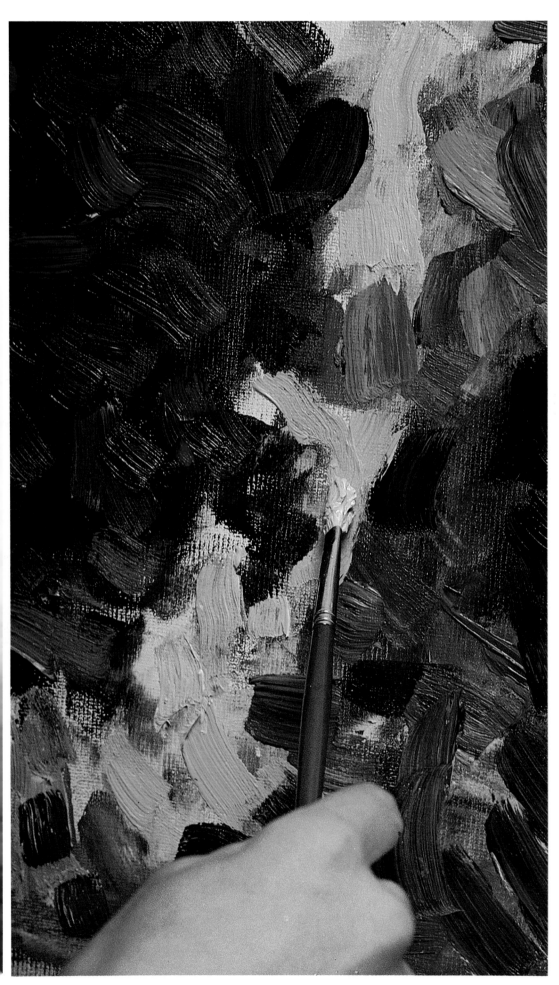

If necessary, use a small brush to define the tree shapes, thereby strengthening the contrast between the outline of the trees and the sky (left). Here the artist is dabbing in the pale pink sky — this throws the dark shape of the tree into clear silhouette.

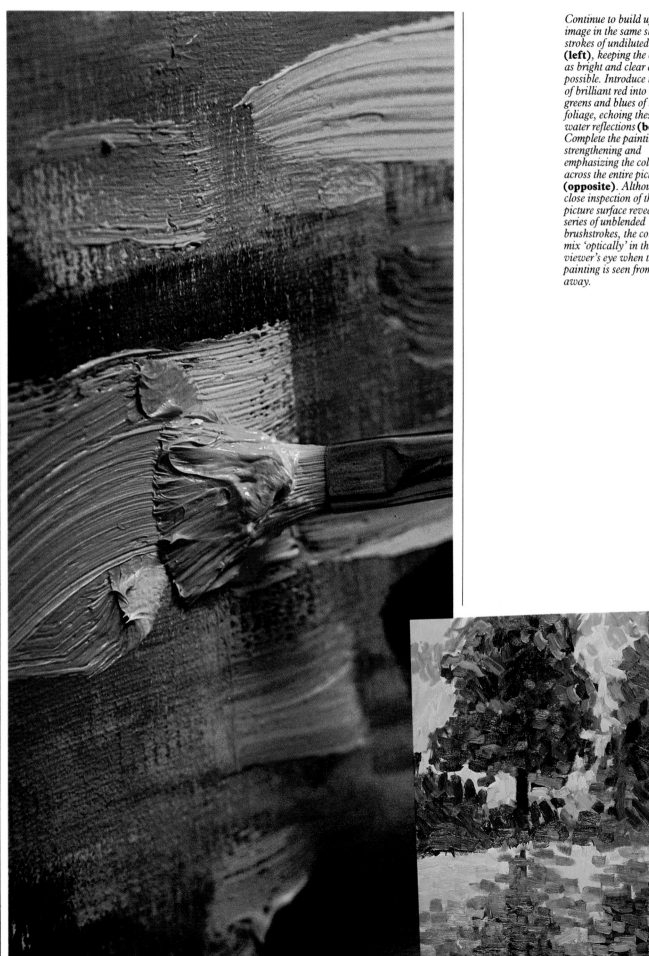

Continue to build up the image in the same short strokes of undiluted paint **(left)**, *keeping the colours as bright and clear as possible. Introduce touches of brilliant red into the greens and blues of the foliage, echoing these in the water reflections* **(below)**. *Complete the painting by strengthening and emphasizing the colours across the entire picture area* **(opposite)**. *Although a close inspection of the picture surface reveals a series of unblended brushstrokes, the colours mix 'optically' in the viewer's eye when the painting is seen from further away.*

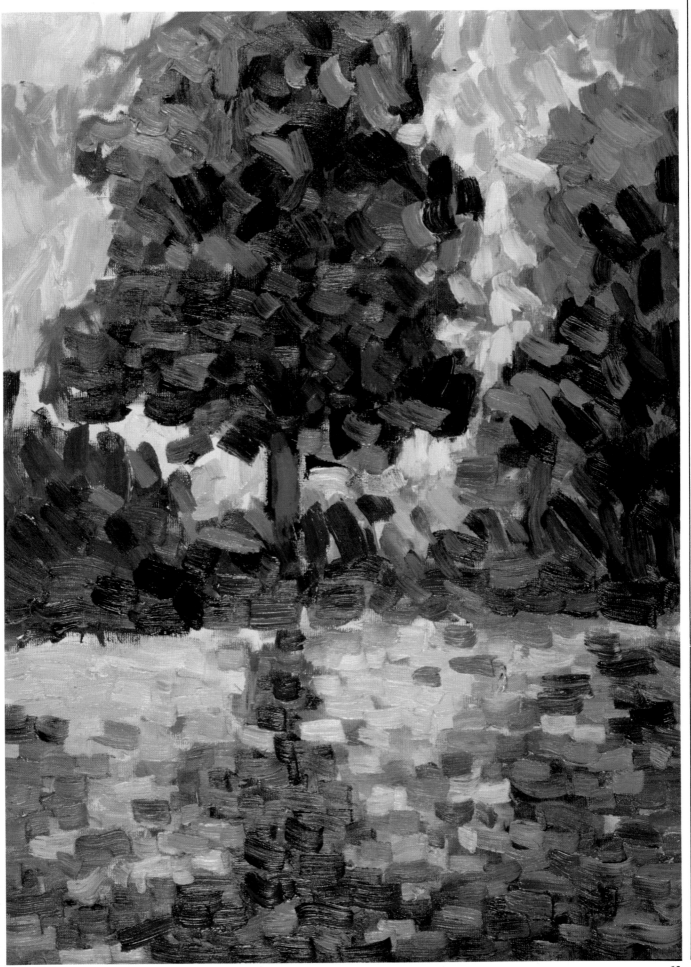

COUNTRY STREAM

Working from a photograph can be unsatisfactory because it means accepting a fixed viewpoint from the outset. There are occasions, however, when working from a two dimensional image can be an advantage. A photograph already shows the subject in two-dimensional terms, thus part of the interpretive process has already taken place, leaving the painter free to experiment and to translate the flattened subject into more abstract terms. Here the artist has used a photograph as a starting off point, using it as a basis for a personal and colourful interpretation of the subject by exaggerating and abstracting the pattern of the trees and flowers and the warm glow of light.

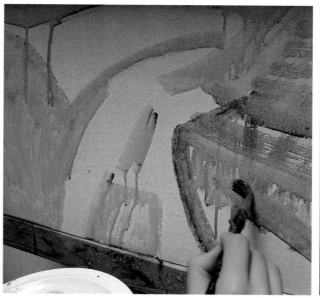

Sketch in the general subject with a very thin wash of green mixed with turpentine, quickly blocking in the main shapes with a large, soft brush (left). Scrub in the basic composition, introducing other shapes and colours with rapid, broad brushstrokes (below).

Use a broad bristle brush to block in the pale blue shape of the stream with thickish paint (opposite).

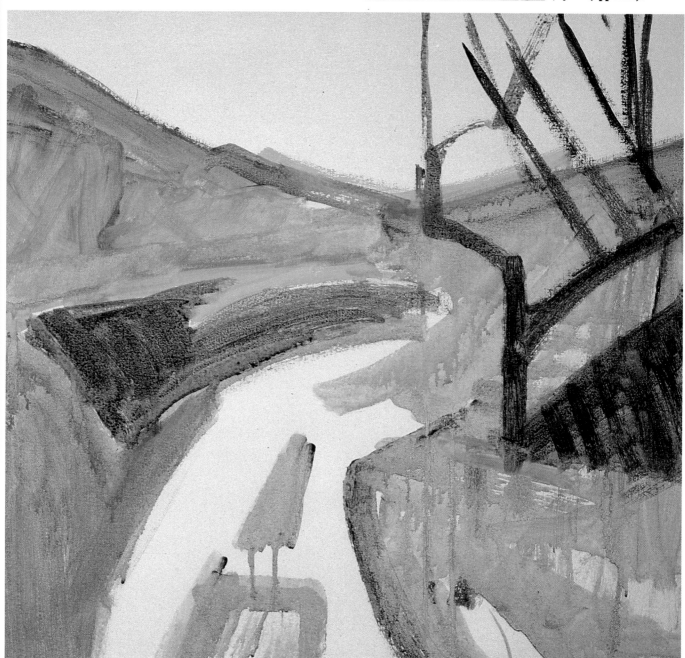

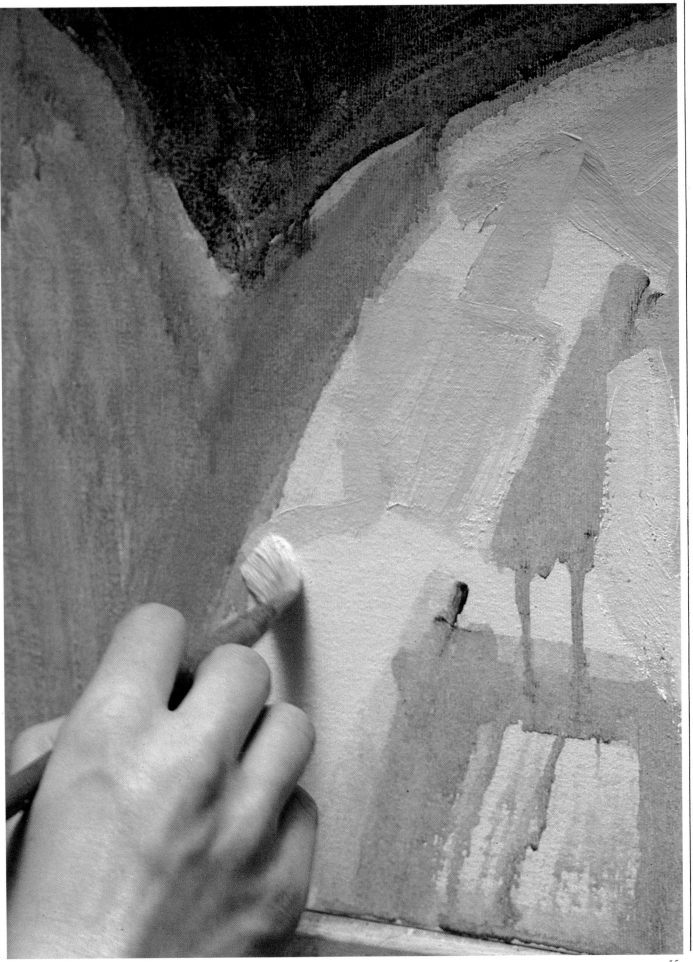

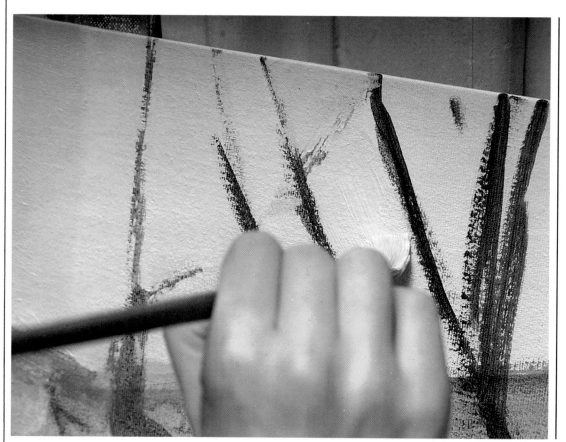

Paint the shapes of the spaces between the trees and branches in pale pink **(left)**. Do this with a large brush, making the shapes simple and geometric, in keeping with the angular, abstract quality of the painting.

Thicken the paint and lighten the tone of the colours, introducing cooler tones and colours into the picture. Work quickly over the painting with broad brushstrokes **(below)**.

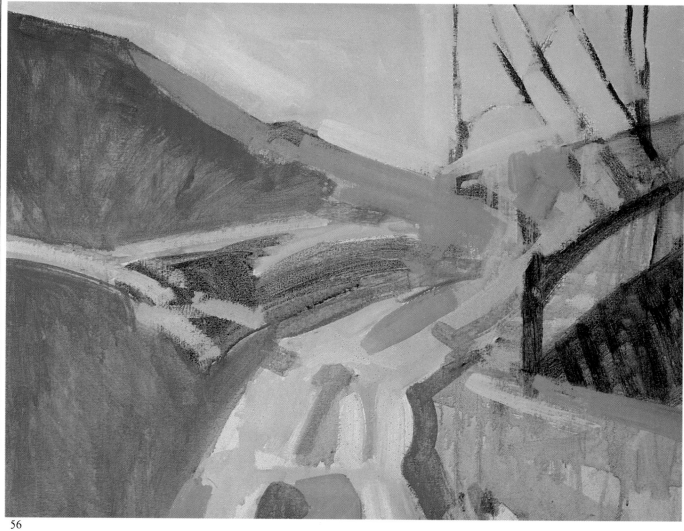

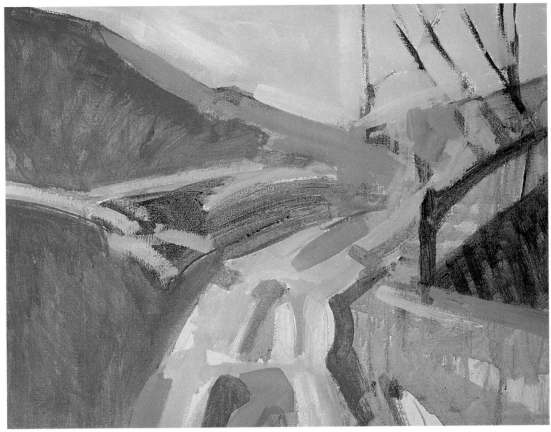

Apply the colour in a general way, building up the image with broad brushstrokes. Concentrate on developing the main shapes and the overall rhythms of the composition, and to see each element in terms of colour and shape instead of trying to get a realistic likeness.

Work into the tree shapes with red and black, and block in the thick slabs of green, building up texture by varying the quality of the brushmarks (**right**).

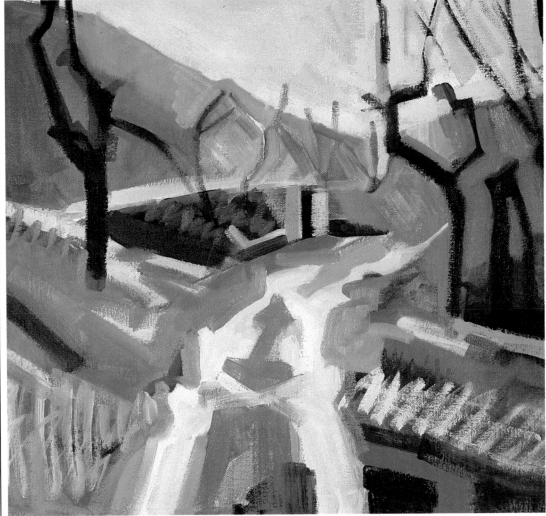

57

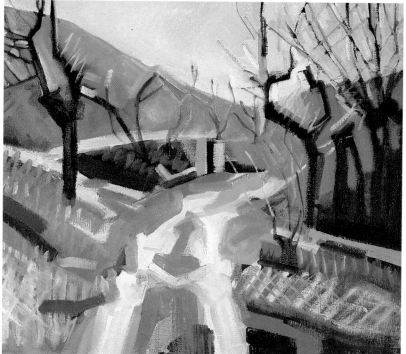

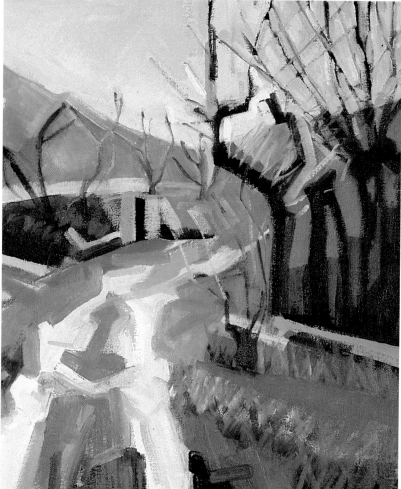

Use a fine brush to define the linear shapes in the composition and to touch in details of colour. Emphasize the darker tones with ultramarine blue **(top)**.

Elaborate the texture in the foreground with finely cross-hatched brushstrokes of red, green and yellow, weaving them across the previous work **(above)**.

Develop the foreground and complete the painting by dabbing in the white flowers **(right)**.

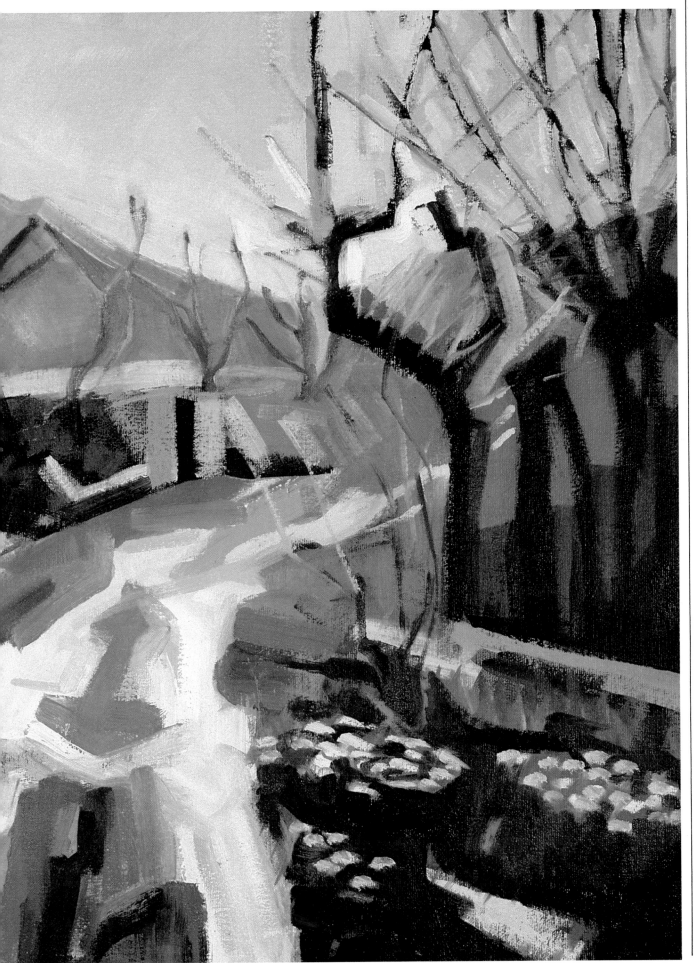

PALM TREES

Tropical palm trees and exotic shrubs offer plenty of scope for the artist who is interested in experimenting with paint textures and surface pattern. The spiky leaves and richly textured trunks of these trees inspired this artist to use a variety of brushmarks and techniques to create different surface textures, including scraping the wet paint with a painting knife, applying colour with the fingers and laying thickly impastoed areas over a transparent, wash-like background.

Oil paint is slow drying — very thick paint can take months to dry properly. This makes it possible to manipulate the colour on the surface of the picture surface for a considerable time, allowing you to experiment with a variety of textures, patterns and techniques until you are satisfied with the result. If you make a mistake with the colour it is an easy job to scrape it off and start again.

No details are included in the picture. Instead the image is almost entirely dependent on strong shapes and rich textural effects for its success. Nor has there been any attempt to create form by shading or highlighting the subject. The trees, leaves, foreground and distant mountain are left as flat, graphic shapes which are arranged on the canvas into a balanced, harmonious composition.

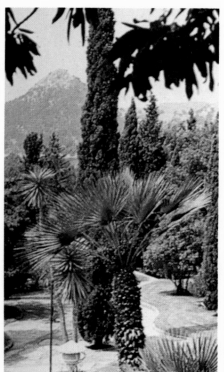

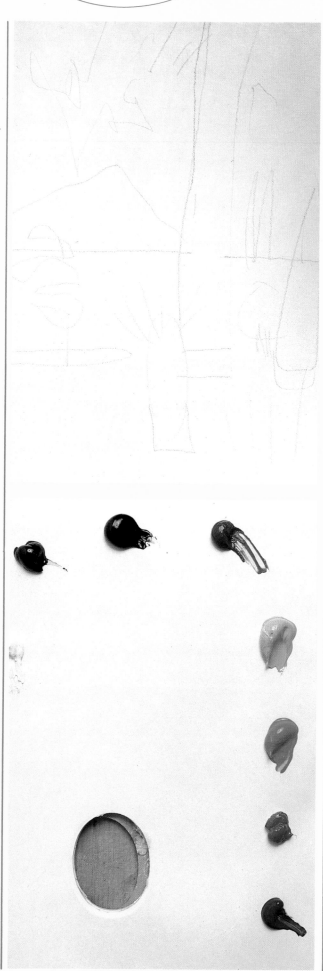

Sketch in the outlines of the general composition in pencil (left), including just enough information in your drawing to act as a guide to the painting.

Squeeze out a selection of colours onto your palette. For this painting the artist used black, sap green, raw umber, cadmium yellow, chrome green, cadmium red, and ultramarine blue.

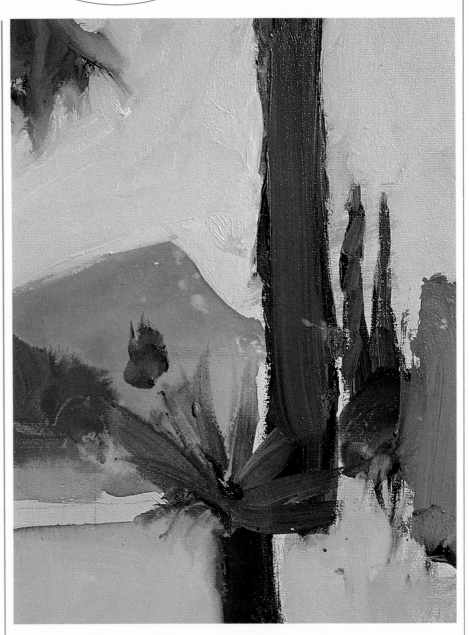

Use a large brush to lay in the main colour areas, diluting the paint with turpentine to get a thin, quick-drying wash for this initial blocking-in **(below)**. *Do not worry if the paint runs or looks messy — this will eventually be worked into and built up with further colour* **(below right)**.

Gradually thicken the paint, and continue blocking in until all the main areas are established **(above)**. *Vary the texture of the paint to indicate the textural quality of each component in the picture. For example, the tree trunk is painted in smooth, vertical strokes; the feathery palm tree is described with short wispy brushmarks.*

Now, work into the painting, breaking up selected areas of flat colour to bring out the various textures in the subject. Use the side of a painting knife to lay thin lines of raised paint **(right)**.

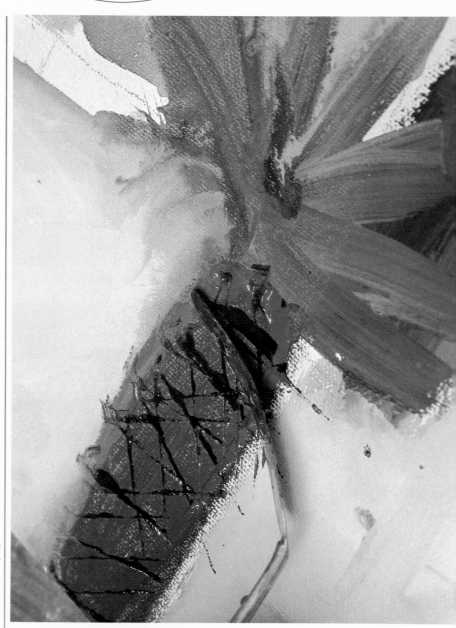

Scratch into wet colour with the end of the paint brush — here **(below)** the artist has used this technique for the leaves of the foreground tree.

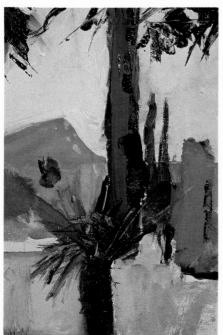

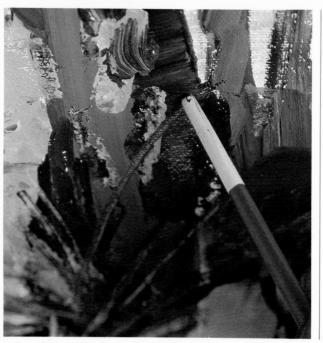

White canvas shows through where the paint is scraped back, producing a light coloured cross-hatched effect **(left)**. These scratched textures can vary in density and character, but must always be made while the paint is wet.

*Apply colour straight from
the tube, blending this into
the wet underpainting in
order to 'mix' new, streaky
colours directly onto the
canvas* **(right).** *Do not
overdo this technique,
otherwise the paint becomes
overmixed and the colours
turn muddy.*

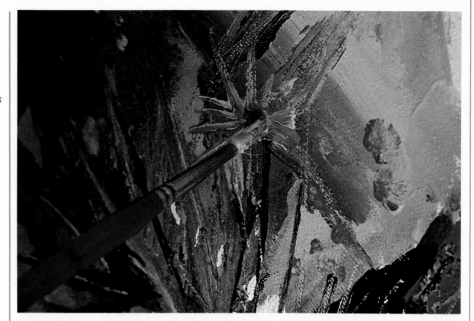

*Use your fingers to smudge
on thick blobs of colour*
(right).

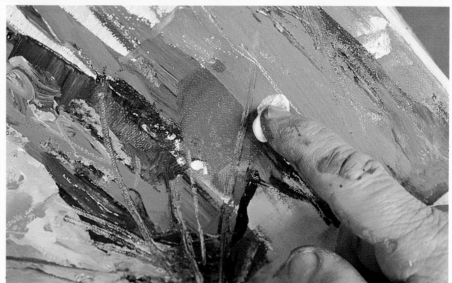

*While the paint is still wet
'draw' into the picture using
a sharp instrument or the
end of your painting knife*
(far left). *Touch in areas
of fine detail with a small
sable brush* **(left)**.

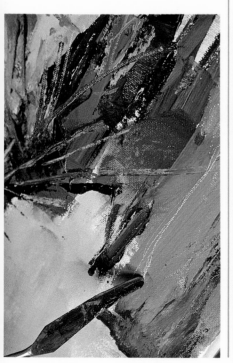

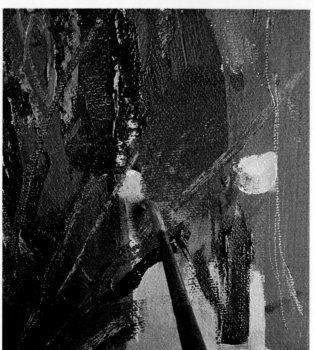

Stand back from the painting in order to assess the whole image. Lighten or darken those areas which have become lost during the painting process in order to maintain interesting overall tonal contrasts **(right)**.

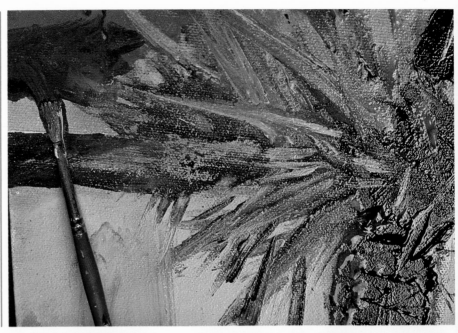

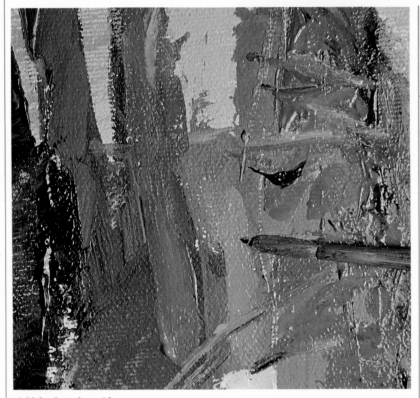

Add final touches with a small brush, taking this opportunity to relieve dead, uninteresting areas with dabs of contrasting colour **(above)**.

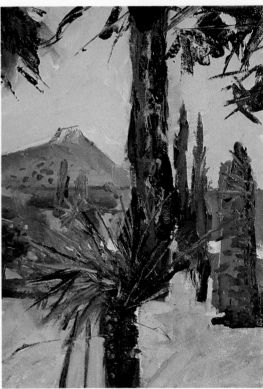

The completed painting **(above)** shows a variety of texture and surface pattern, all quite simply achieved. The subject is not realistically treated, but is used as a vehicle for some creative and exciting experiments with colour, shape and — above all — texture.